TANGLED CIRCLES
- and -
MANDALAS

52 *Drawings* to Finish & Color

by JANE MONK

Author of the International Best-
Selling Tangled Art Series

Creative Publishing
international

CONTENTS

INTRODUCTION

Welcome to another interactive book in the Tangled Art series of coloring books. When I first started teaching Zentangle® after becoming a Certified Zentangle Teacher in 2010, my motto was "Teaching the Art of Zentangle." This still holds true for me today with this series of Tangled Art coloring books. Throughout the series, I have provided a good solid base of knowledge and instruction, not only about color theory and coloring techniques, but also about how to create tangle patterns and combine them in different ways to help you create your own wonderful tangled art.

In *Tangled Circles and Mandalas*, I teach you how to bring your own circle and mandala patterns to life, and, in addition, I provide 32 fully completed tangled art patterns. As you color each illustration, your brain is taking in and learning how it is constructed, and how patterns are repeated and melded. Finishing the partially completed illustrations will further teach you how to put patterns together, and at the end you can move on to create your own tangled art circles and mandalas.

As with my other interactive books, all of my illustrations have been hand drawn using a simple fine-point black ink pen on paper, combining my own freestyle drawings and tangle patterns with Zentangle patterns to create a fresh approach to coloring. I have also included a section at the back for you to test out color combinations and techniques as well as to practice some of the tangle patterns I have shown you how to draw. Or you can simply go straight to the 52 illustrations and interactive drawings and color them with colored pencils, watercolor paints, inks, markers, or any coloring medium you choose. Most of all, have fun!

Jane

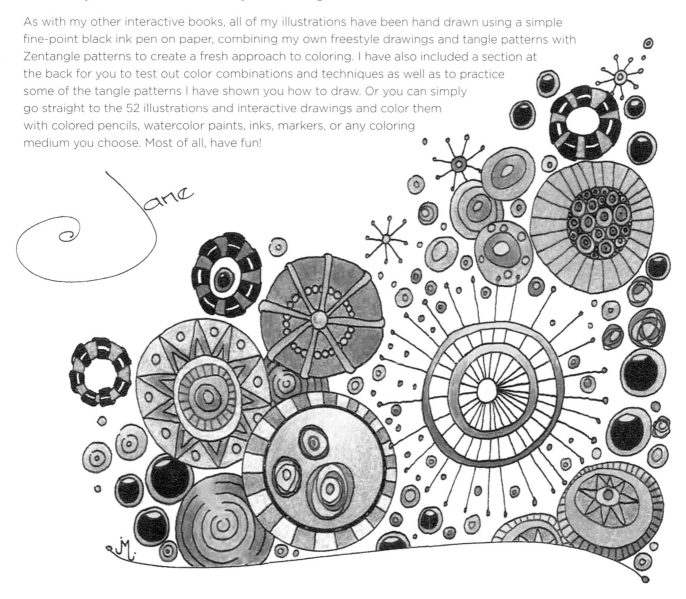

CIRCLES, MANDALAS, SYMMETRY, AND SACRED GEOMETRY

The circle is one of the very core shapes that we identify with. It is the shape of the Earth, the Sun, and the Moon. It is a symbol that we see repeated everywhere around us. The circle is the basic shape of a mandala. So what is a mandala?

The word *mandala,* which comes from the ancient Indian language of Sanskrit, means both circle and center, and can represent both the visible world and invisible world. It has long been held as sacred, and has rich symbolism within many cultures around the world. The mandala can be seen in Native American art, Hindu yantras, Tibetan sand paintings, Gothic roses, stained glass windows in Christian places of worship depicting various religious scenes, ancient carvings—the list could go on and on.

The basic circle on which the mandala is based is also the first enclosed archetype of sacred geometry, which is a visual language that uses shapes to explain our universe and creation. It is a concept that aligns our universe and spirituality with geometric concepts and shapes. It is thought that contemplating sacred geometry through the process of construction and subsequent meditation can lead to enlightenment.

One of the most recognizable sacred geometry patterns is perhaps "The Flower of Life," a symbol that can be found in all major religions around the world. The Flower of Life is drawn using only circles using what is called sixfold symmetry. It starts with a circle in the center, with subsequent circles then added around its circumference.

Creating mandalas using circles and repeating simple shapes and patterns to create seemingly complex designs can be incredibly satisfying and pleasing to the eye, especially when used in conjunction with symmetry.

Reflectional symmetry is where one half of an image is an exact reflection of the other, as seen in a mirror. More often than not, rotational symmetry is used when constructing mandalas. This is where the image is rotated around a central point and appears two or more times.

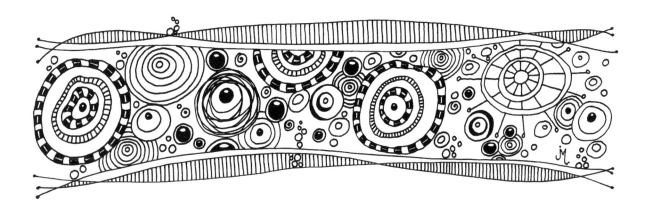

BASIC TOOLS

Here's a list of what you need to create and color circle patterns and mandalas.

Paper. To ensure longevity of your final artwork, use an artist-quality paper with a good weight and smooth surface. Artist-quality paper is usually acid free, and a good weight will hold up to various coloring mediums you might want to use. Alternatively, you can purchase ready-made journals in book form, or you could make your own. General copy paper is good to use in the early stages of designing and spacing individual mandala patterns.

Pencil. A 0.5mm mechanical pencil with an HB lead is a great pencil—it does not need to be sharpened, and ensures that all of the lines you draw are the same thickness. This will help when precision marks are called for. Always test any pencil you use to see how the lead erases from the surface of your chosen paper: If it is too soft, the graphite can work its way into the surface of the paper; too hard, and it can leave a mark that cannot be removed.

Eraser. I like to use a Sakura foam eraser. A good kneadable eraser will also work. Just be sure to test the combination of paper, pencil, and eraser before you start on your work of art.

Ruler. Any straight ruler will work. Make sure that it has no irregularities or gouges in the drawing edge. A metal ruler will be a good choice, although you cannot see through it. For making smaller lines, I use a small plastic set square (triangle-shaped ruler), which has the added bonus of being able to see through it.

Protractor. A full 360° circle protractor with a 6" (15.2 cm) diameter is a nice size, as the outside can be used as a template for a finished mandala as well. Linex makes a 4½" (11.4 cm) diameter protractor that has various-sized circle templates within it, which is very useful.

Compass. A good style of compass to use is called a bow compass, which also has an adjustable pencil holder that various ink pens can easily fit into.

Circle templates. There are various brands of circle templates available. I like to use Staedtler metric circle templates.

Ink pens. Use a fine-tip ink pen that has archival black ink in it. Sakura Pigma Micron pens do not bleed when other mediums are used over them, so they are a good choice. Most art supply stores have tester pens available, so you may want to take a piece of the paper you will be using to the store and test various pens to see how they work prior to making a purchase.

Coloring mediums. Use any coloring medium you prefer. Later in this book I discuss water-soluble wax pastels. These can be used in conjunction with markers and colored pencils as you choose.

HOW TO USE A COMPASS

A compass is used to draw circles and arcs. It can also be used to mark points along a circle to expand a design with more circles and arcs.

There are various brands and types of compasses. I like to use a bow compass, which has a wheel in the center of the two arms to allow for fine adjustments. I also like a compass that enables me to swap one arm with an adaptor to accommodate a variety of ink pens.

Once you have loaded your pen into the adjustable arm holder, bring the compass needle point and the pen nib together and ensure that they align. Doing this every time you use your compass will ensure a consistent starting point, which allows you to repeatedly achieve a circle diameter with little variation.

When the arm of the compass is opened, the distance from the sharp point to the point of your pencil or pen nib in the other arm is half the diameter of the final circle that will be drawn. Therefore, the sharp point needs to sit firmly in the center of where you want the circle to be on the page. The circle is then drawn with the arm that sits on the outside.

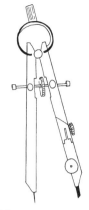
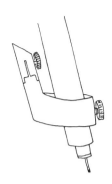

A bow compass.

A compass with an adjustable arm holder.

Make sure there is no "slack" in the arms, and that they are firmly apart. Place the point in the center and place the other arm with the pen or pencil onto the paper. Holding the compass by the top, lean it slightly backwards and twist the top so a smooth circular line is drawn. You may wish to practice this a few times if you have not used a compass before. Remove the compass from the paper. Adjust the diameter for any other circles you wish to draw and continue in the same manner as above.

HOW TO USE A PROTRACTOR

A protractor is used for marking points at various degrees for drawing angles through the center point of a circle. There are various types, including half-protractors and the two examples at right.

The black line on the center bar of the full protractor indicates the center of the circle. Always mark this point first.

Position the 0 mark at the top of the circle and mark each point where you wish to draw a line for your mandala. For more information, see "Creating a Base Skeleton," opposite.

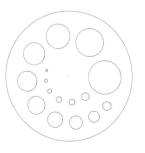
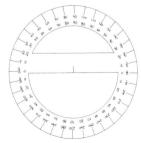

A Linex protractor.

A 360° full protractor.

CREATING A BASE SKELETON

Use a pencil to draw the mandala skeleton or template so you can erase the lines after you have added the patterns and your mandala is complete.

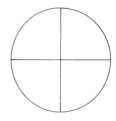

STEP 1: Crosshairs drawn through the center mark over a full-size circle.

USING A COMPASS

Step 1: Use the compass to lightly draw a circle the size you want for your finished mandala. Use the small indentation that the compass made in the center of your circle as a guide to draw a vertical and horizontal line to create four even spaces.

Step 2: To complete the template, use the compass to create smaller, evenly spaced circles as guides within the larger circle.

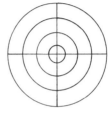

STEP 2: Concentric circles added to the mandala template.

Step 3: Use the protractor to mark evenly spaced lines in the parameters of the circle. You may not want to use so many lines in the smaller center of a mandala circle, so only draw them part of the way to the center. This will keep the center a little clearer of lines.

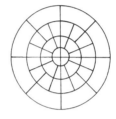

STEP 3: Additional angles marked on the mandala template.

USING A PROTRACTOR

Step 1: Mark the center point for your mandala onto the paper. Position the protractor on the paper, ensuring the center point lines up with the point you made on the paper. Make marks at the 0°, 90°, 180°, and 270° positions. Remove the protractor and draw a vertical line from the bottom mark to the top through the center point. Next draw a horizontal line from the left mark to the right mark passing through the center point.

STEP 1: Vertical and horizontal lines passing through the center point.

Step 2: You can use these points to line up your protractor and mark in other equally spaced lines. For example, the 45° angle marks will be at the numbers 45, 135, 225, and 315. This will result in eight equally spaced segments around the circle. (See page 123 for an example of a sixteen-segment template.)

STEP 2: Protractor angles to create eight segments in the circle.

Step 3: If you want smaller segments, mark points at 22.5, 67.5, 112.5, 157.5, 202.5, 247.5, 292.5, and 337.5. This will result in sixteen equally spaced segments around the circle.

Draw in concentric circles to make as many segments as you wish to create your mandala patterns.

STEP 3: Protractor angles to create sixteen segments in the circle.

ODD-NUMBERED SEGMENTS

When you wish to use an odd number of segments in a particular mandala, you will start with an odd number of radiating spokes. Because there is an odd number, the lines do not go through the center point to the other side. It is important to mark the center first so you can determine where to stop each line. You will see in the example that not all of the lines intersect, but instead meet at the center.

Three radiating spokes. Mark each angle at 0, 120, and 240.
Six radiating spokes. Mark additional angles at 60, 180, and 300. This will turn your odd-segmented mandala into an even-segmented mandala.

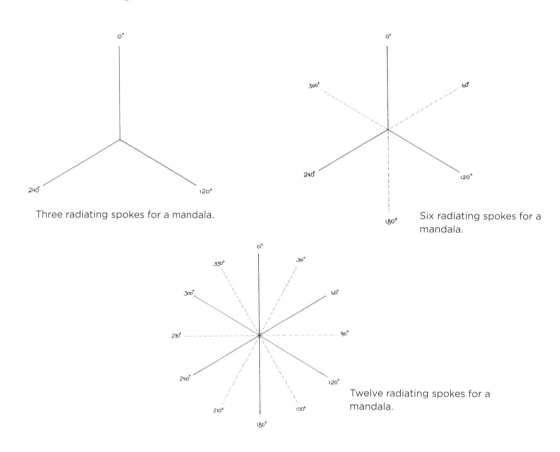

Three radiating spokes for a mandala.

Six radiating spokes for a mandala.

Twelve radiating spokes for a mandala.

Twelve radiating spokes. Twelve spokes are created when you mark additional angles at 30, 90, 150, 210, 270, and 330. However, if you omit the lines marked at 60, 180, and 300 in the previous example, you will create a 9-segmented mandala.

Use the protractor to mark out angles to create different-sized spacing. Not all segments need to be of equal size. Play with it to see what you can come up with.

Remember that if you have an even number of segments, an alternating pattern can be created. If you have an odd number of segments, you cannot create an alternating pattern.

MANDALAS WITHOUT MATH

If you don't have a protractor or a compass you can still draw a mandala. First, decide how big you wish your finished piece to be and take a clean sheet of paper that will accommodate that size. The groundwork for creating the base structure of the mandala will be in pencil, so we can erase it at a later stage. You will need to gather up some round shapes in various sizes that you can use. Try things like a CD, various-sized bottle caps, an egg ring, a round cookie cutter, or even coins. Anything that looks like a usable size can work here. Start by placing a dot in the center of the page. This will be the center from which the mandala radiates outward.

Step 1: Using a ruler, lightly draw in crosshair lines—a horizontal and vertical line going through the center point you marked on the paper. This creates four sections and will allow you to ensure your circles are centered.

Step 2: Choose a shape to trace a small circle around the center point.

Step 3: Draw a larger circle using the same method as the previous step.

Step 4: Now draw the largest circle to create the outside of the mandala circle. This is the base structure for an even-numbered mandala. That means the number of sections will be of an even number, even if you divide each section into smaller parts.

Step 5: To create additional sections, divide each section into two. If you have a protractor, these lines are a 45° angle.

STEP 1: Vertical and horizontal crosshairs as guidelines.

STEP 2: First circle centered on crosshairs.

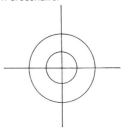

STEP 3: Inside circle centered on crosshairs.

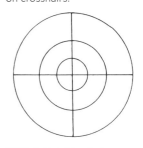

STEP 4: Outside circle centered on crosshairs.

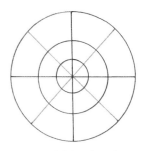

STEP 5: Additional angles to create more segments.

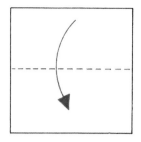

STEP 1: First fold.

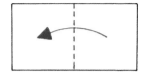

STEP 2: Second fold.

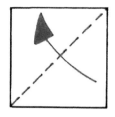

STEP 3: Third fold.

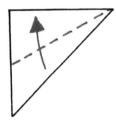

STEP 4: Optional fourth fold.

So what about making evenly spaced angles without math and without a protractor or compass? You'll need to make a mandala marking template. It is really simple to do.

Step 1: Take a square of paper approximately 8 inches [21cm] square. A sheet of copy paper is a good size to cut into a square. Fold the square piece of paper in half on the horizontal line. This creates a rectangle shape.

Step 2: Fold the rectangle in half on the vertical line. This creates a square shape again.

Step 3: Fold the square on the diagonal line, creating a triangle shape. This fold creates 8 segments.

Step 4: If you make an additional fold on the diagonal line indicated, 16 segments will be created on the final square when opened.

Step 5: When the paper is opened, the fold marks correspond to the following degrees on a full circle protractor: 0°, 22.5°, 45°, 67.5°, 90° , 112.5°, 135°, 157.5°, 180°, 202.5°, 225°, 247.5°, 270°, 292.5°, 315°, and 337.5°.

Step 6: Draw over the fold marks with a ruler and pen so you can see the lines more clearly. Trim the final folded square into a circle to use as a marking template for mandalas.

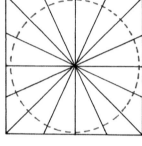

STEP 5: Paper opened out with fold lines drawn and circle marked for trimming.

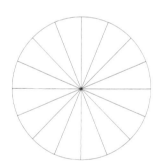

STEP 6: Paper trimmed to a circle shape, ready to use as template for marking a mandala.

Tip: Place an old CD on top of the template you created, ensuring it is centered. Transfer each of the marks onto the edge of the CD with a permanent marker. Make notches by filing the outside edge of the CD at each mark with a metal nail file. You can then use this as a more solid template.

CONCENTRIC CIRCLE SPACER GAPS

Once you have the basic lines drawn to create segments, you may wish to add more circles to create your mandala. In the example below, top left, I created three circles for my mandala.

When I draw in each segment, I may not want a pattern blending into the next segment (see top right). To create a buffer, I draw in circles to create spaces between the segments. I can also use these to create additional patterned sections, or as a guide where to stop a particular pattern. Draw the spacer circles in pencil so they can be erased later, though you may want some of these lines to show in the finished design. They can be drawn in ink first, or you can go over them when finalizing the design.

In the example shown bottom left, I have drawn the base structure in red, including the extra three spacer circles. See how I use the lines as guides to create my pattern. Not all of the lines are needed or wanted in the final design (bottom right), which is why it is best to draw the base structure in pencil so it can be erased.

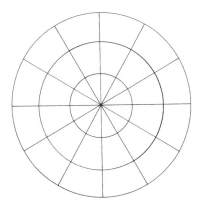

Mandala with three concentric circles.

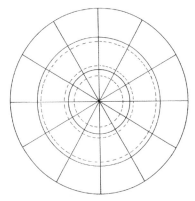

Mandala with additional circles drawn as spacer gaps.

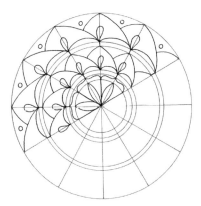

Mandala patterns drawn over part of the base structure.

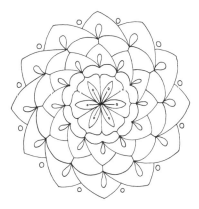

Completed mandala with all lines and circles erased.

PATTERNS AND SHAPES

Each of the following designs has been drawn using a sixteen-segment mandala base skeleton on which I have drawn two circles. Some examples have a progressively changing design, which enables you to see the potential each design has and how different they can look by changing only one or two components of the same design. Try some combinations in the Technique Tryouts section (see page 123). If you want your mandala to be symmetrical, when you draw a pattern in one section make sure to repeat it in the same area of each section.

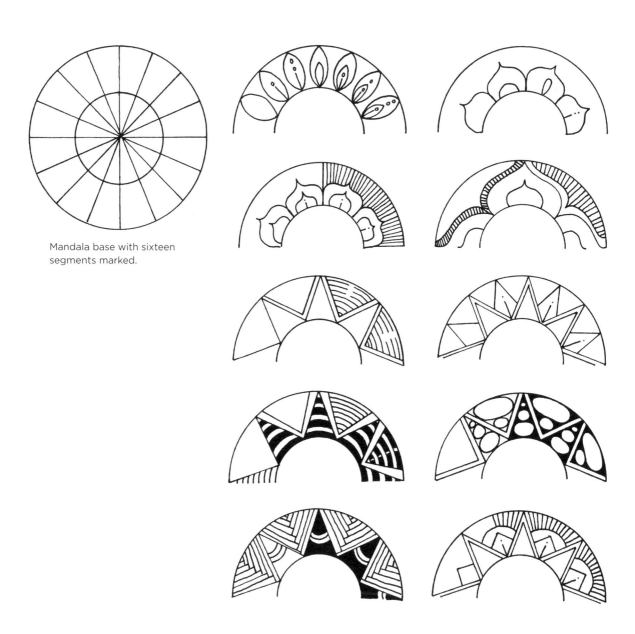

Mandala base with sixteen segments marked.

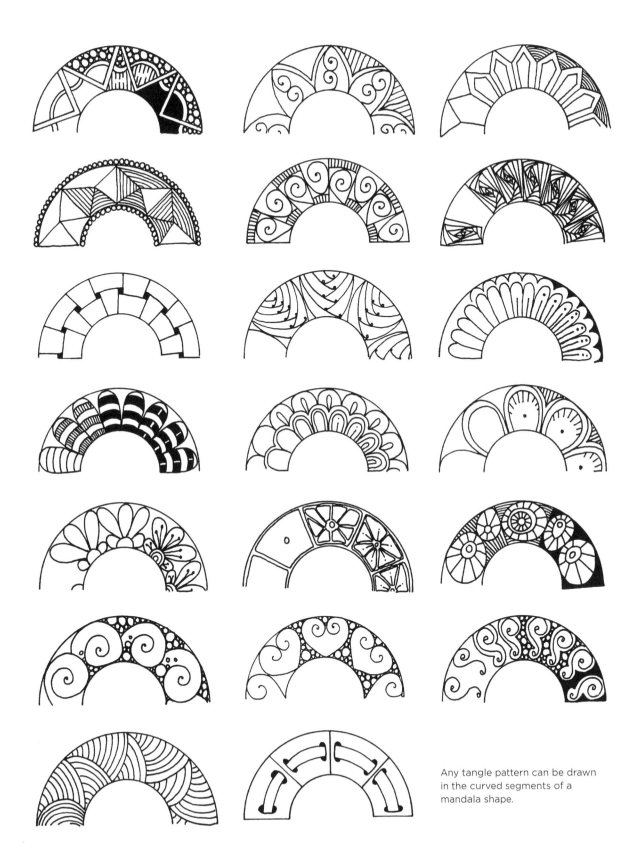

Any tangle pattern can be drawn in the curved segments of a mandala shape.

FREEFORM CIRCLES

So far we have looked at the more formal type of mandalas made with precision tools, but what about the freeform, more organic style of mandala or circle? Freeform circles can also be built up from the center outward, although I often draw the outside circle first to set the parameters for each design.

To build layers up from the inside, start with a small circle as the center. Add a second circle around the first. Fill the space created with spokes.

Starting from the center out.

Be mindful of the number of segments you make and how you wish to color them. An even number of spokes will create an even number of segments, and an odd number of spokes an odd number of segments. An even number allows you to color alternate segments.

Try adding spikes and spokes in different combination. Make odd-shaped circles to create interest. Build up layers of patterns around the center. Placing repeated shapes evenly spaced around the center will give your finished circle or mandala a more pleasing look.

Adding spacer circles to create gaps.

I have provided a range of circles so you can study them and use as inspiration to create your own circles and mandalas. How many different designs can you come up with?

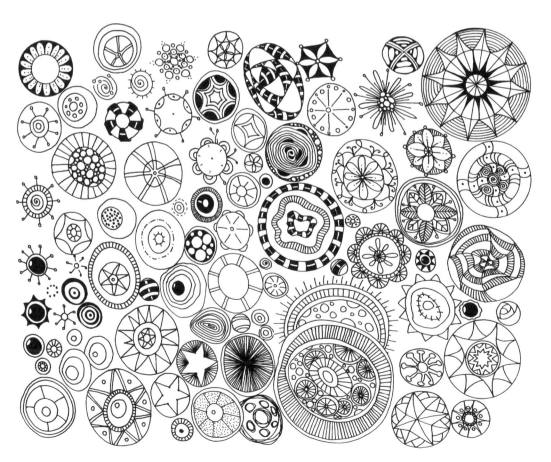

COLORING CIRCLES AND MANDALAS

In this section, I show how to create three-dimensional effects with color and shading, and how to create "glow" with colored pencils, including where to put highlights and lowlights. In this example, I have used Faber-Castell Polychromos pencils in Deep Scarlet Red, Orange Glaze, Cadmium Yellow, Grass Green, Leaf Green, Chrome Oxide Green, Cobalt Green, and Violet.

Choose your color palette. I like to choose two to three shades to color each individual element. So you might choose a selection of the same shade with a light, mid-, and dark tone. Or you might like to choose a mix of colors, perhaps a dark purple, a mid-blue, and a mid- to light green.

To create the best effect, start by coloring each element with the darkest tone at the bottom, moving to the mid tone, and then the lightest tone at the top of the element. Color along with me by using the mandala template in the Technique Tryouts section (see page 125).

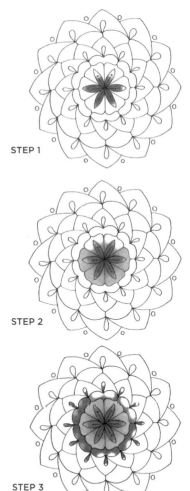

STEP 1

STEP 2

STEP 3

Step 1: Center Petals. Using Deep Scarlet Red, start coloring from the center out using a small circular motion and a light touch. Color a third of each petal. Build the color up so the bottom of each petal is darker than the next section, where the next color will blend in. Next use Orange Glaze to color another third of each petal toward the tip. The final color is Cadmium Yellow. Color in the remaining third of each petal with Cadmium Yellow. Once you have applied one layer of colored pencil, go over each section to help smooth and blend where one color meets the next.

Step 2: Round Two Petals. I have chosen to use only two colors for these petals. Using the same small circular movements, take the Chrome Oxide Green and start coloring at the base of the petals around the previous round. Take note how I have rounded the color up around the sides of each petal to create more dimension. I have used a lighter layer of colored pencil where the colors will blend together. Using Grass Green next, color the remaining portion of each petal.

Step 3: Round Three Petals. In this round I have used the same colors as in the first round. I have also used these colors to color in the little stamen shapes that extend into the next round. Starting with Deep Scarlet Red, begin by coloring up close to the petals from the previous round, creating a rounded shape on both sides of each petal so it forms a W shape. Next use Orange Glaze and build the color up higher, keeping this same rounded shape. Finally, use Cadmium Yellow to color in the remainder of the space. Notice how this creates a natural highlight on each edge.

Step 4: Round Four Petals. In this round I have used three different colors—Violet, Cobalt Green, and Leaf Green—that blend quite nicely into each other. Start with Violet, rounding the color halfway down the left side of each petal, meeting the stamen that protrudes into this round and blending down to the right hand side of each petal. Using a darker color along the edge creates shadow so the petal appears to be coming out from underneath the previous round of the mandala flower. Next use the Cobalt Green (note that this color has a bluish tinge to it that blends nicely with the Violet and the Leaf Green). Create a circular shape that leaves the tip of each petal un-colored. Blend the Cobalt Green down into the Violet at the bottom of each petal. Fill in the remainder of each petal with the Leaf Green.

Step 5: Round Five Petals. This round is basically the same as Step 3, except that the shape created to color each petal is a crescent shape rather than the W shape. Start by using Deep Scarlet Red to color close to the petals from the previous round, creating a rounded crescent shape on the sides of each petal. Next use Orange Glaze and build the color up higher, keeping this same rounded shape. Finally, use Cadmium Yellow to color in the remainder of the space. A glowing natural highlight is created on the edge of each petal. Color in the stamen shapes that extend from these petals with the same color sequence.

Step 6: Round Six Petals. Follow the instructions for Step 4, as this round is exactly the same in both shape and colors used.

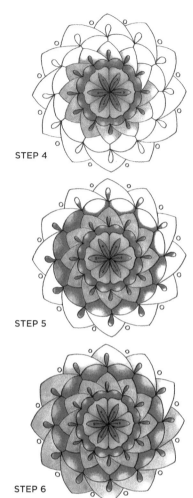

STEP 4

STEP 5

STEP 6

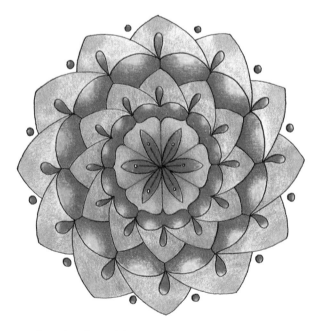

Completed mandala.

Completed Mandala. Color in the remaining circles around the outside of the mandala with the color sequence Deep Scarlet Red, Orange Glaze, and Cadmium Yellow. If you use a light touch and multiple layers, you can achieve an almost seamless blending of two colors into each other. Create a three-dimensional look by using a dark, mid-, and light tone, and by starting with the darker tone at the base of a segment, or where one shape overlaps another to create a lowlight. The glow, or highlight, is achieved by using a much lighter tone at the top or center of a segment, as in the Cadmium Yellow at the top of the mandala segments, and also the Cobalt Green that I have used in the middle of two of the rounds. Use the Technique Tryouts section (see page 125) to test out some different combinations using the colors you choose.

USING WATER-SOLUBLE WAX PASTELS

Next to colored pencils, water-soluble wax pastels are one of my very favorite mediums for coloring. As the name suggests, they are water soluble and have a wax base. The pigment is very fine and blends extremely well. They can also be used dry and applied directly to your paper or other substrate. I especially like Neocolor II water-soluble wax pastels, which are made by Caran d'Ache.

If you use water-soluble wax pastels with water, wait until the surface of your paper has dried before applying more details with a colored pencil or a fine line black ink archival pen.

In the example below, I drew a mandala in black ink on white cardstock and left it uncolored. I then attached it with adhesive to a background page of heavyweight (300g/m2) Fabriano Artistico Extra White hot-pressed watercolor paper. I lightly drew in random wavy shapes, swirls, and tangle patterns with a black fine line ink pen. In this instance I used a Sakura Pigma Micron 01 pen. When the ink is dry, it is not affected by the application of water over it, so it is a good choice when working with water-soluble wax pastels.

I applied the water-soluble wax pastels using a refillable water paintbrush, also called an aqua brush, which has a cylinder barrel that unscrews and fills with water and a nib that is just like an acrylic paintbrush. When you squeeze the barrel, water seeps into the brush. Lightly brush the tip of the paintbrush on your water-soluble wax pastel and apply the color directly to your paper. Keep a piece of paper towel or a soft cloth handy to blot the brush if too much water seeps into it.

You can also apply water-soluble wax pastels directly onto paper and use a wet or damp paintbrush to blend the color, just as you would watercolor paint. Add further layers to increase the intensity of color by loading a damp paint brush with wax pastel and applying it to the paper to create darker areas.

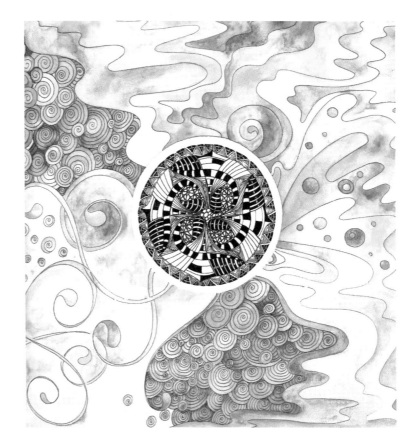

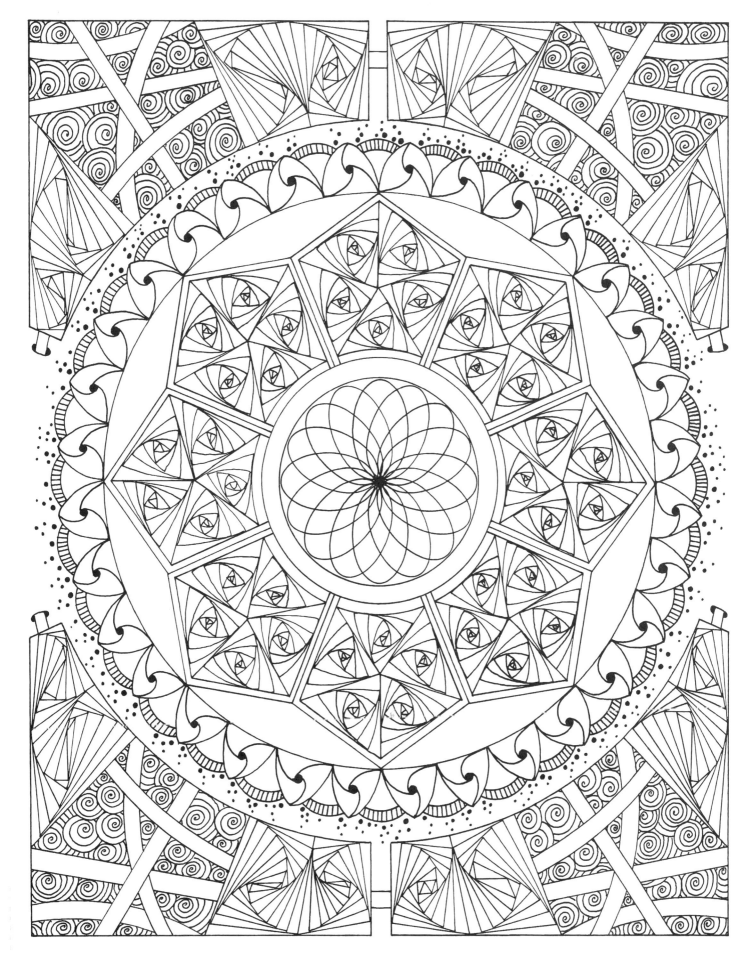

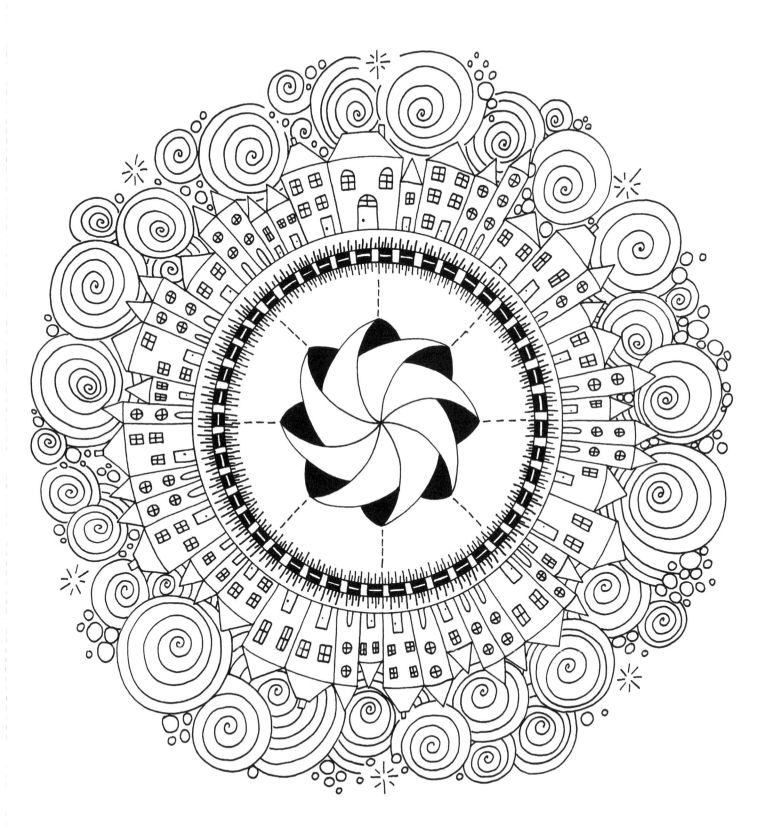

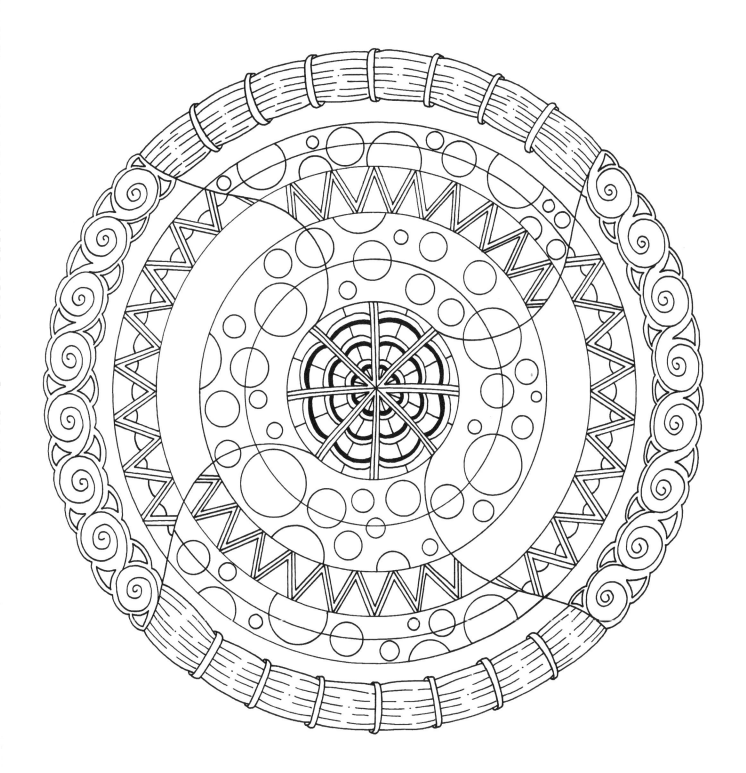

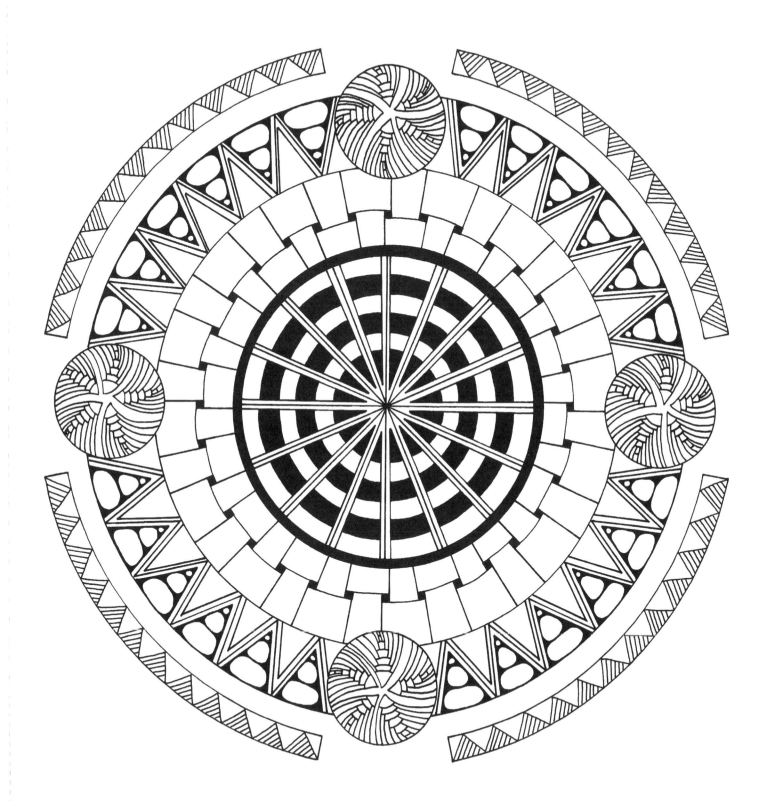

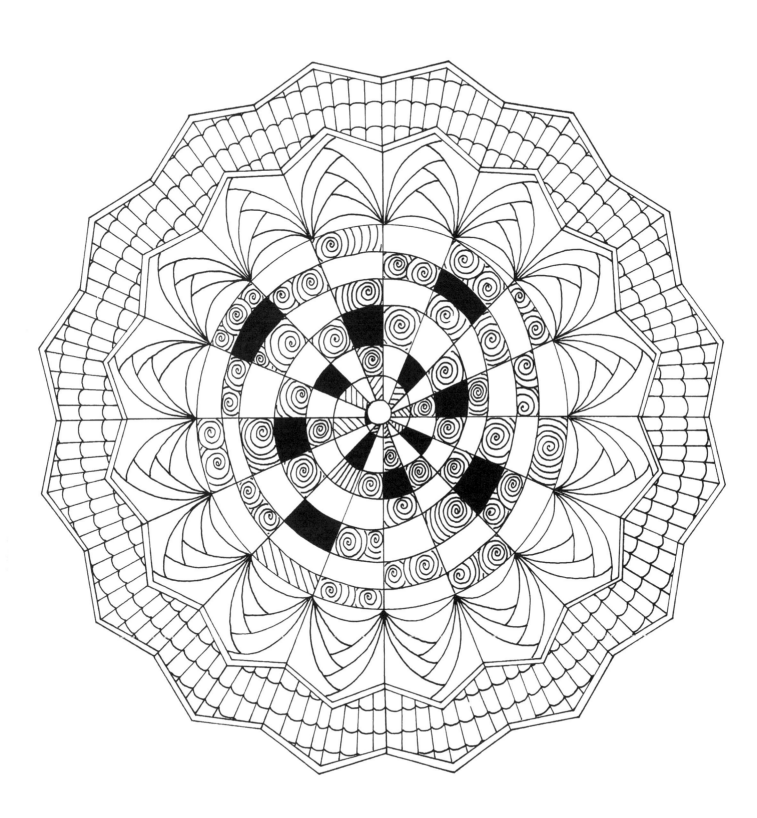

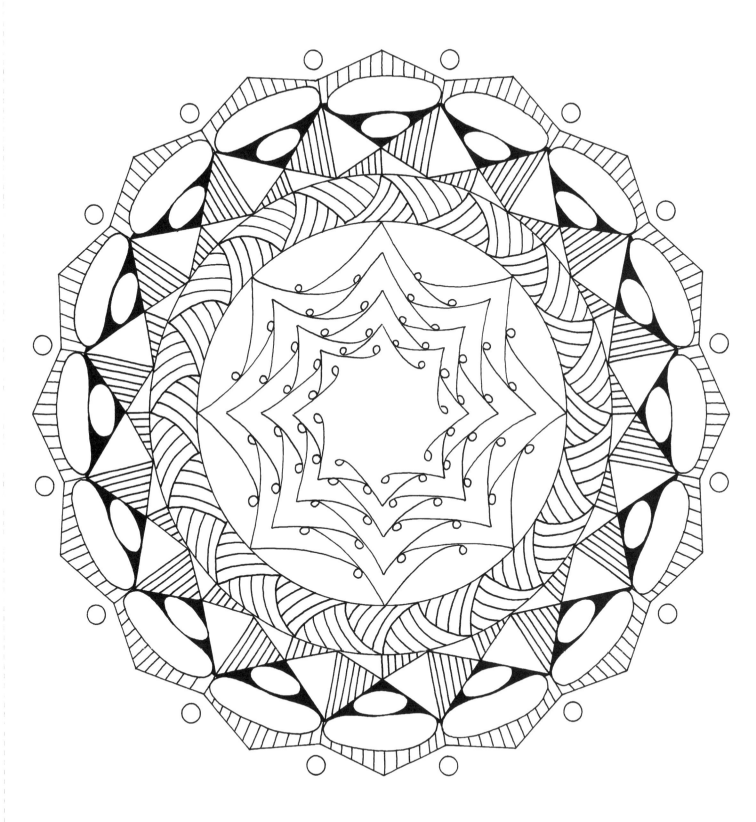

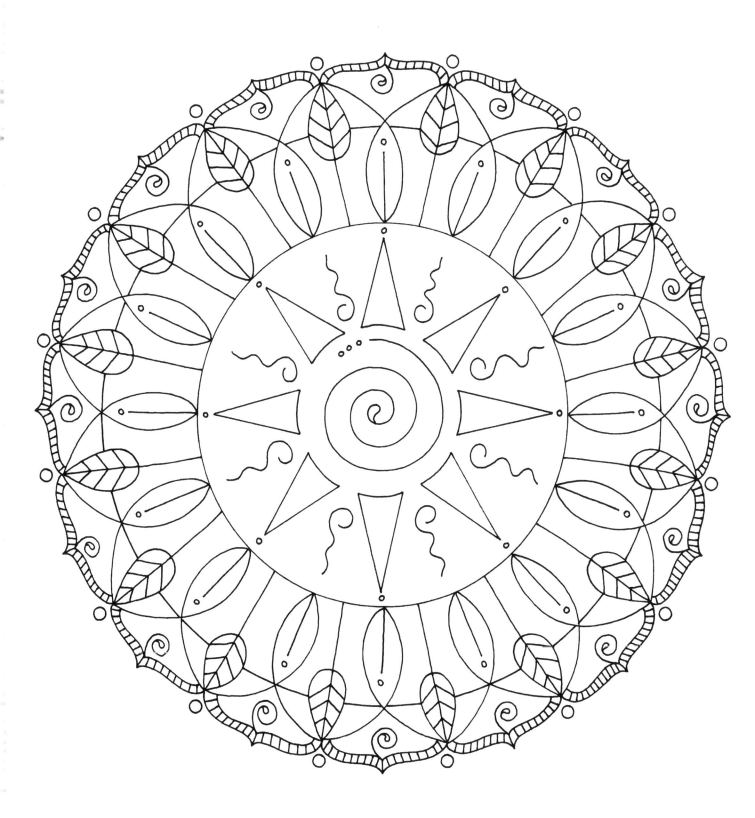

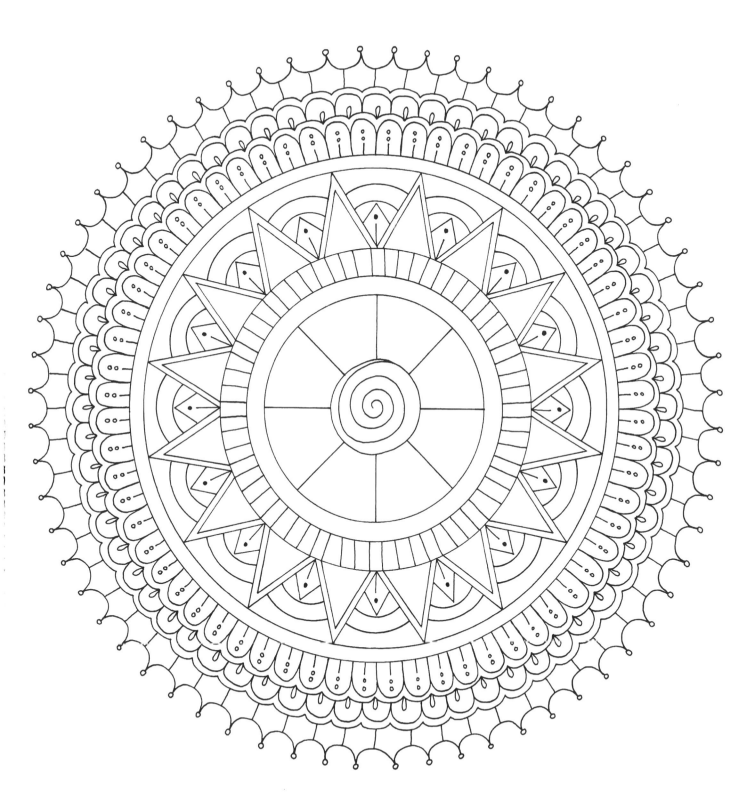

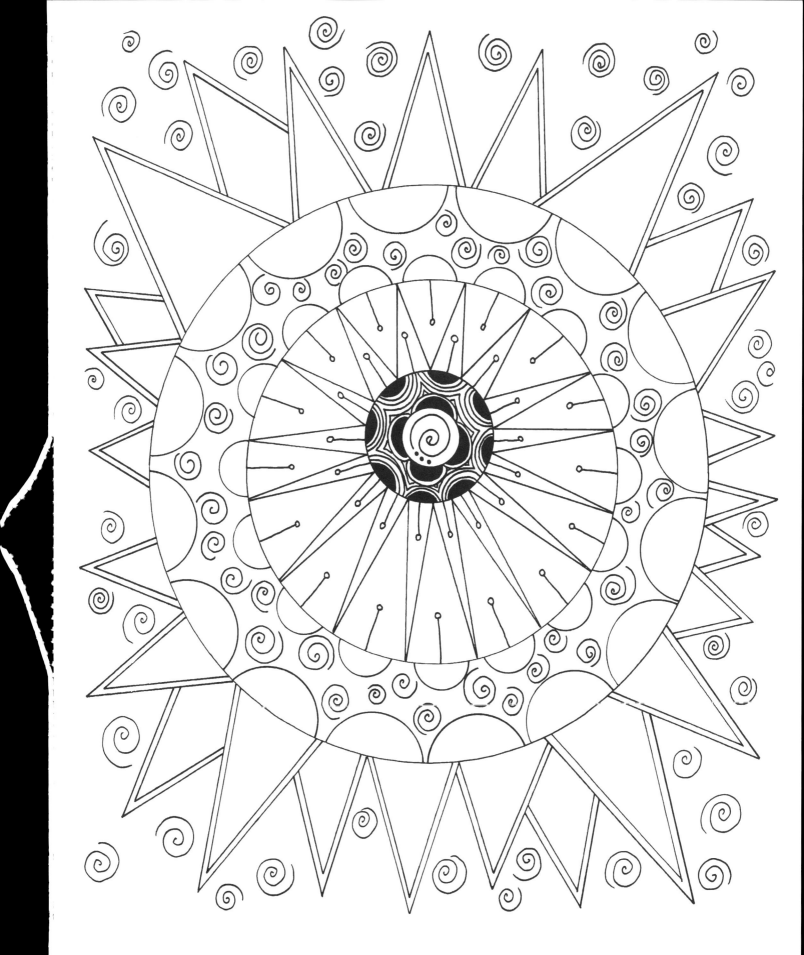

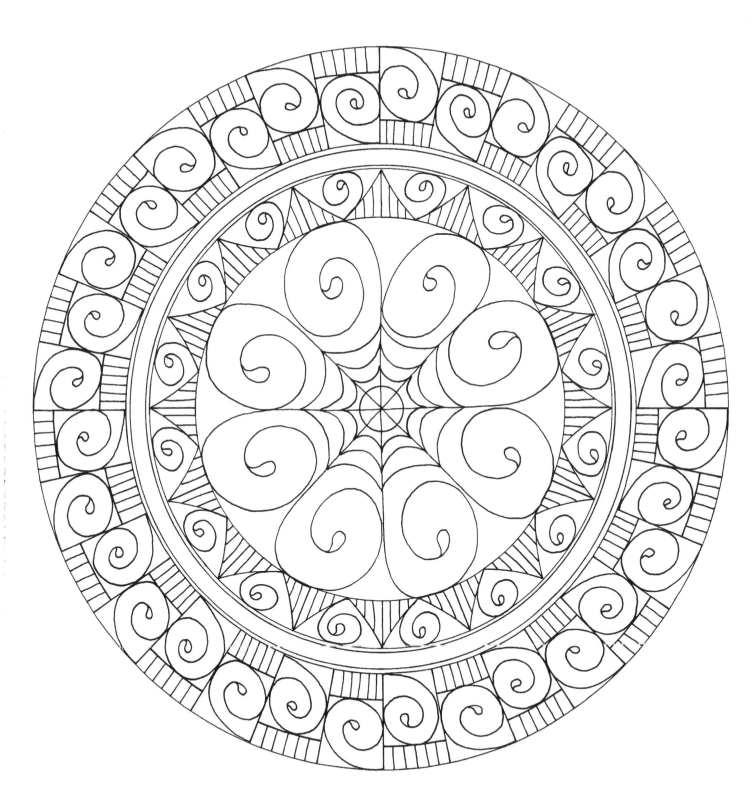

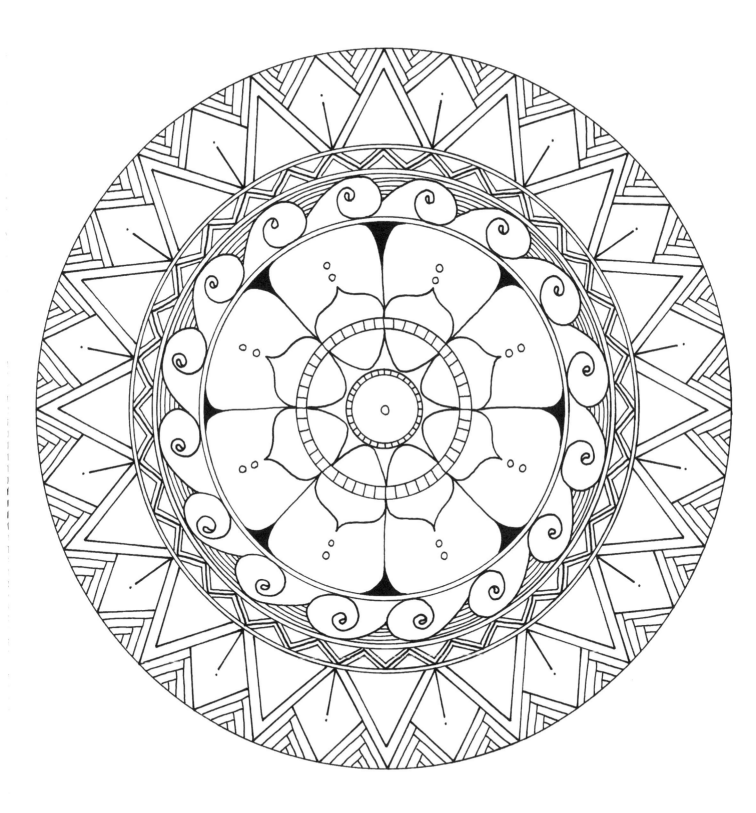

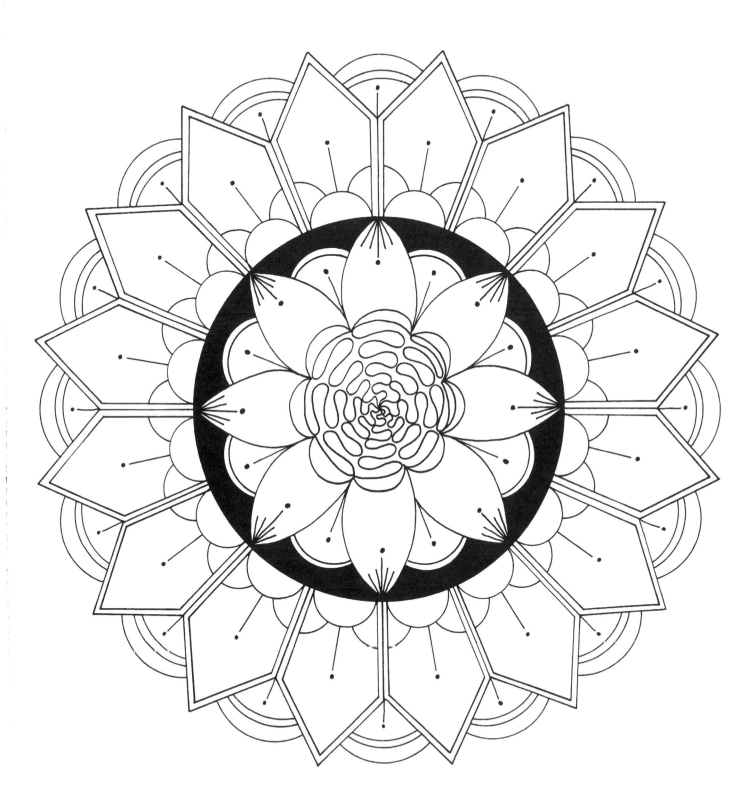

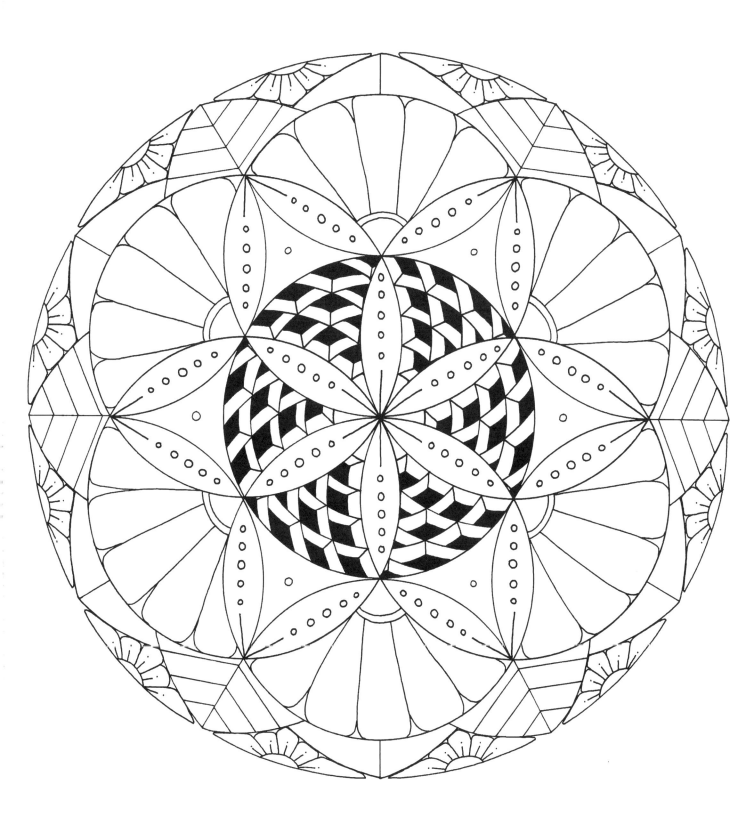

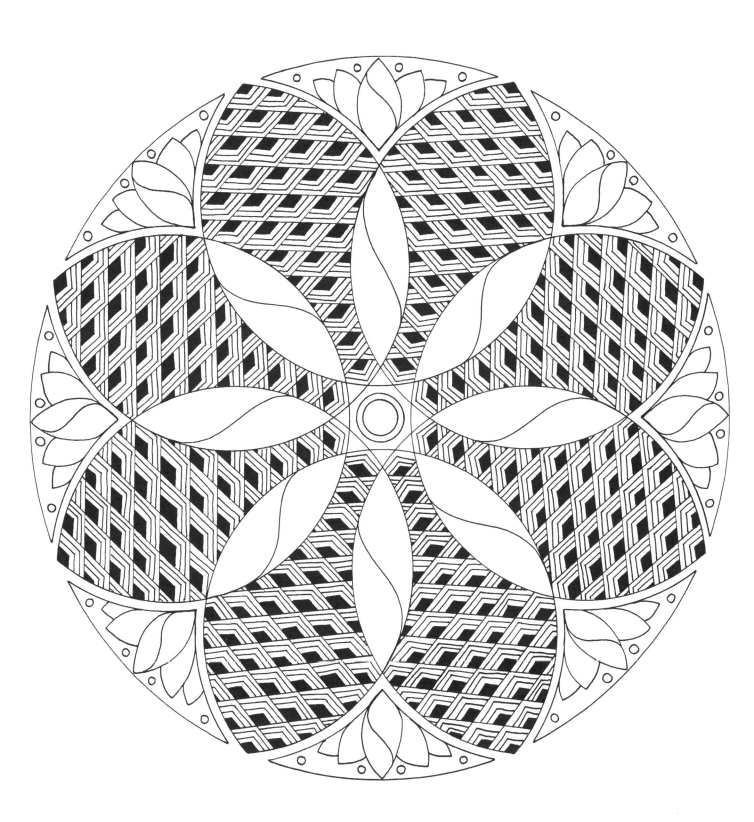

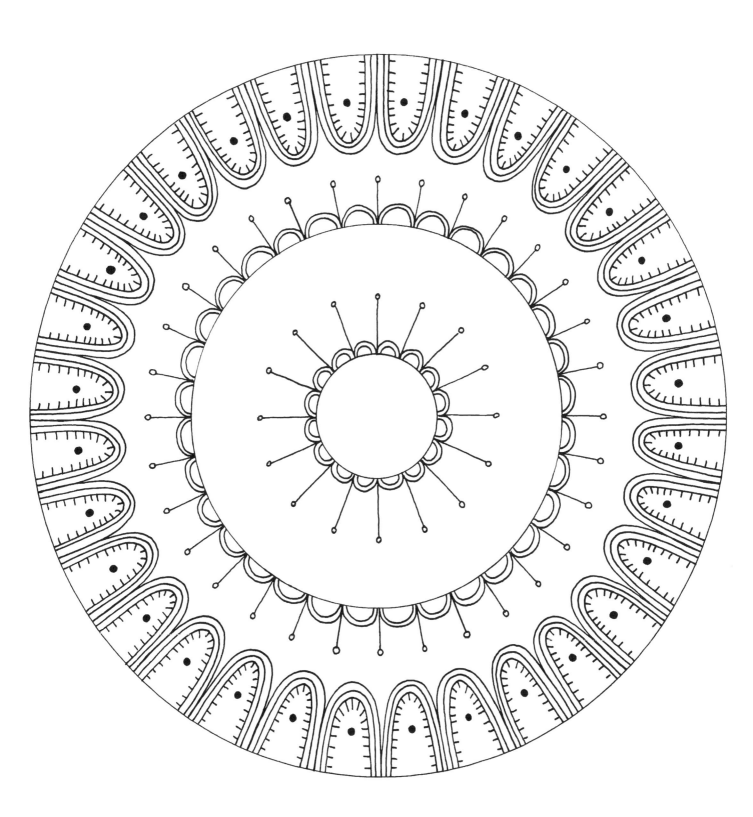

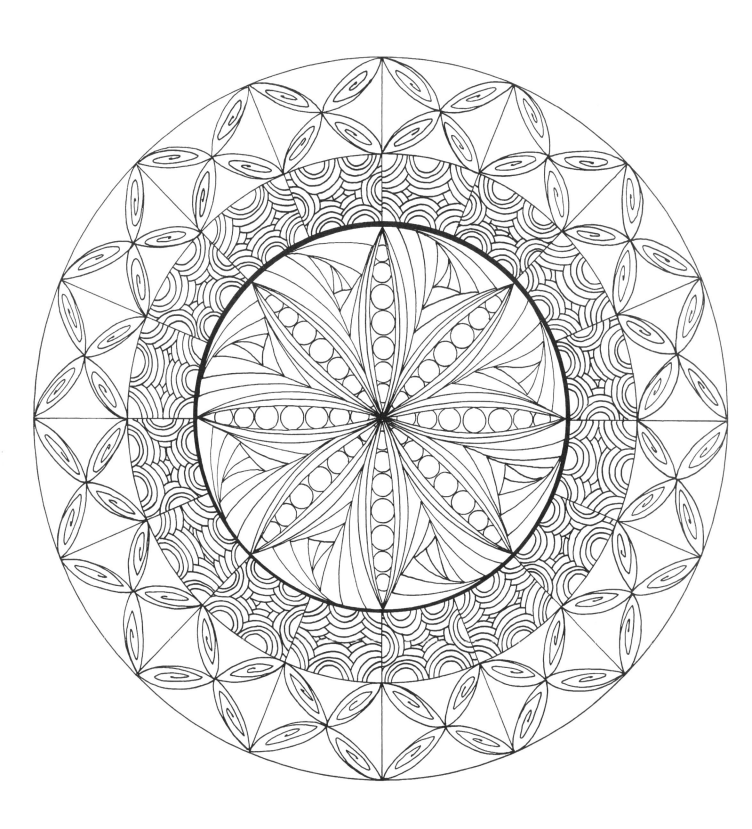

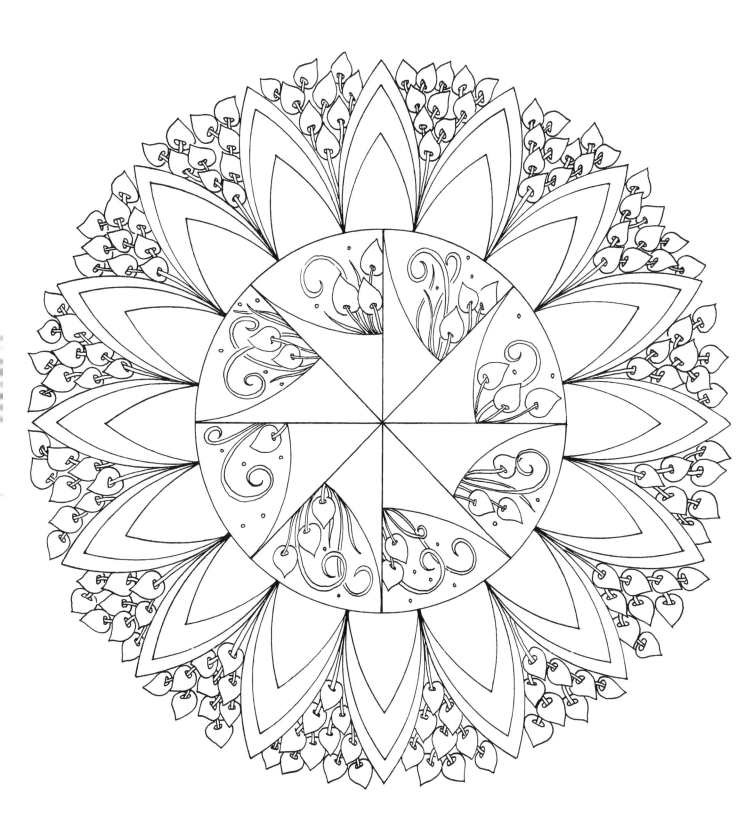

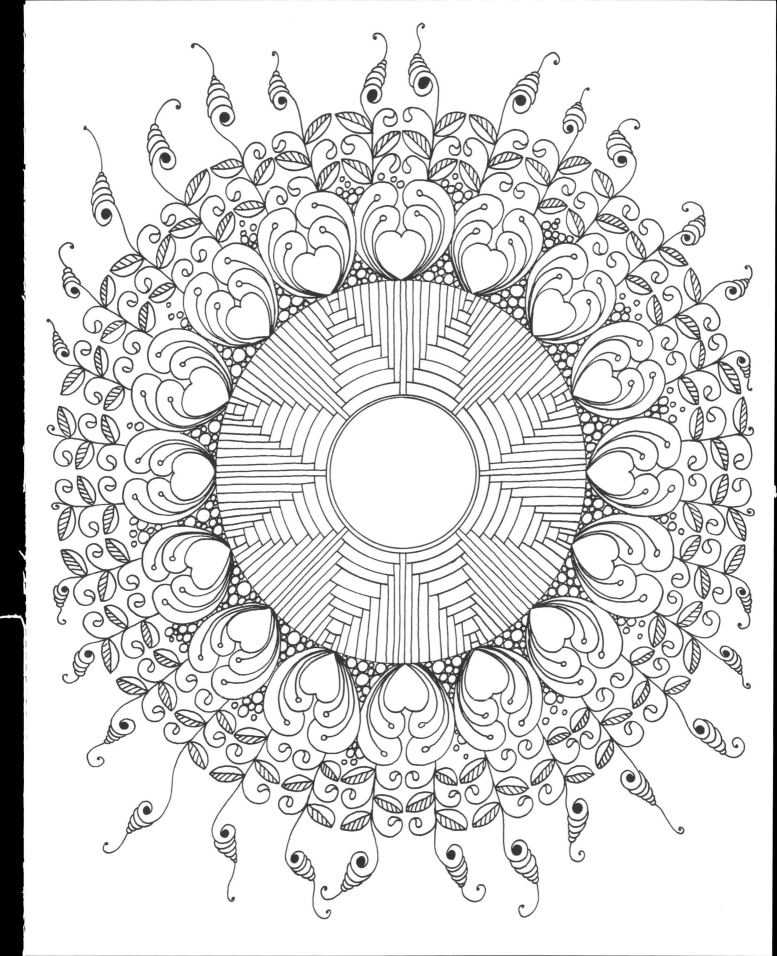

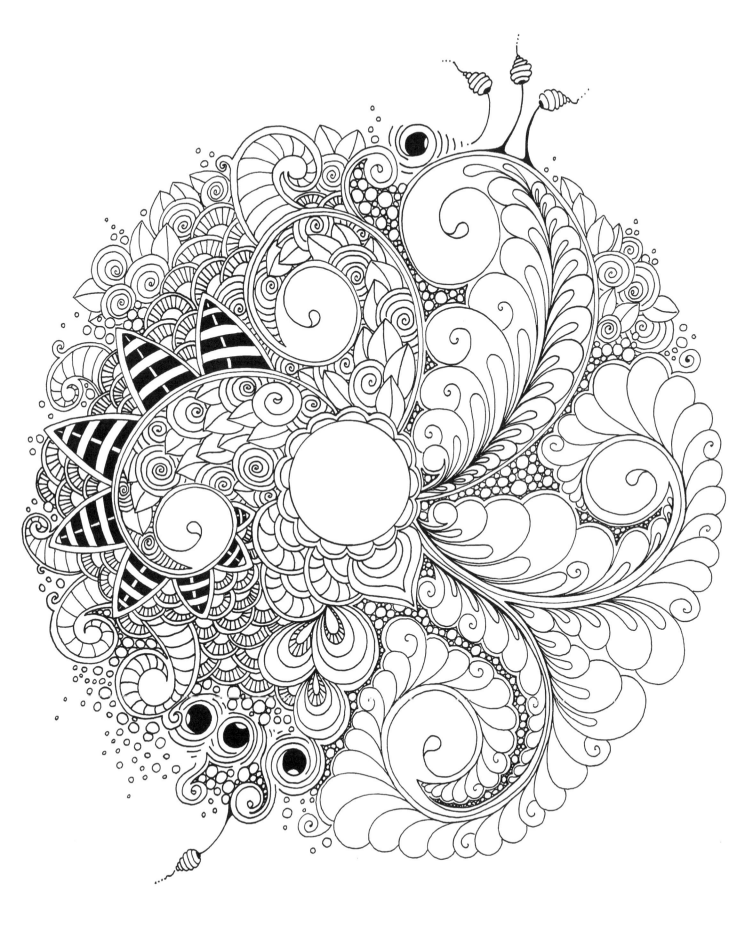

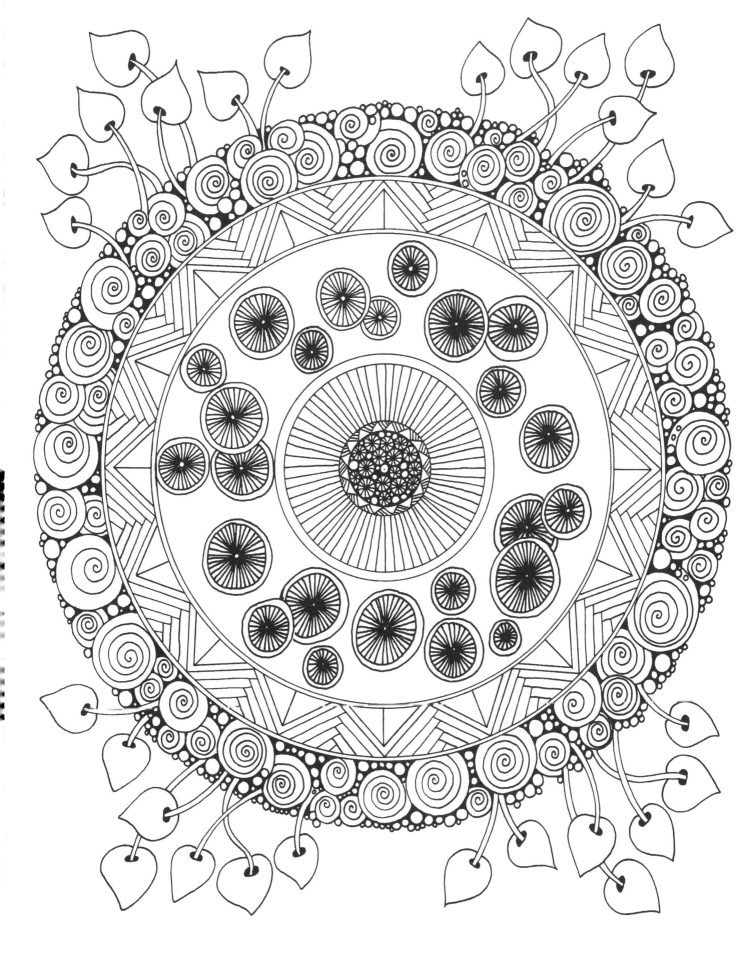

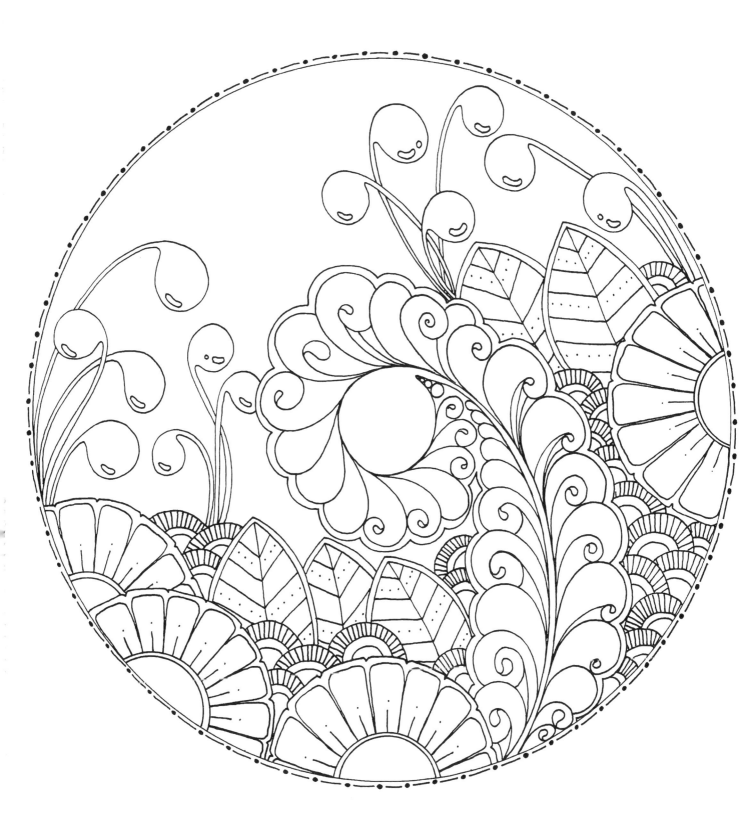

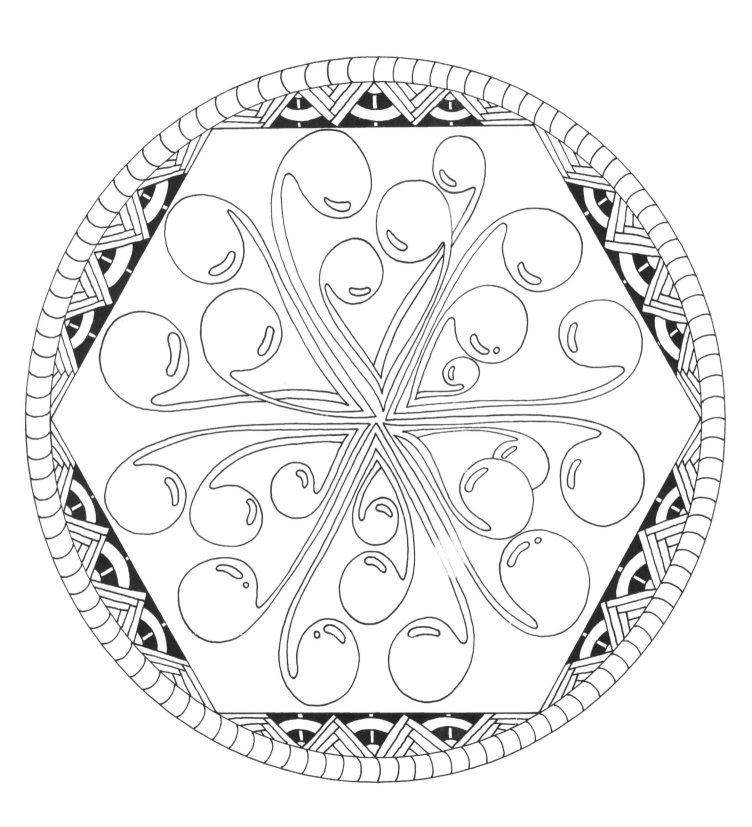

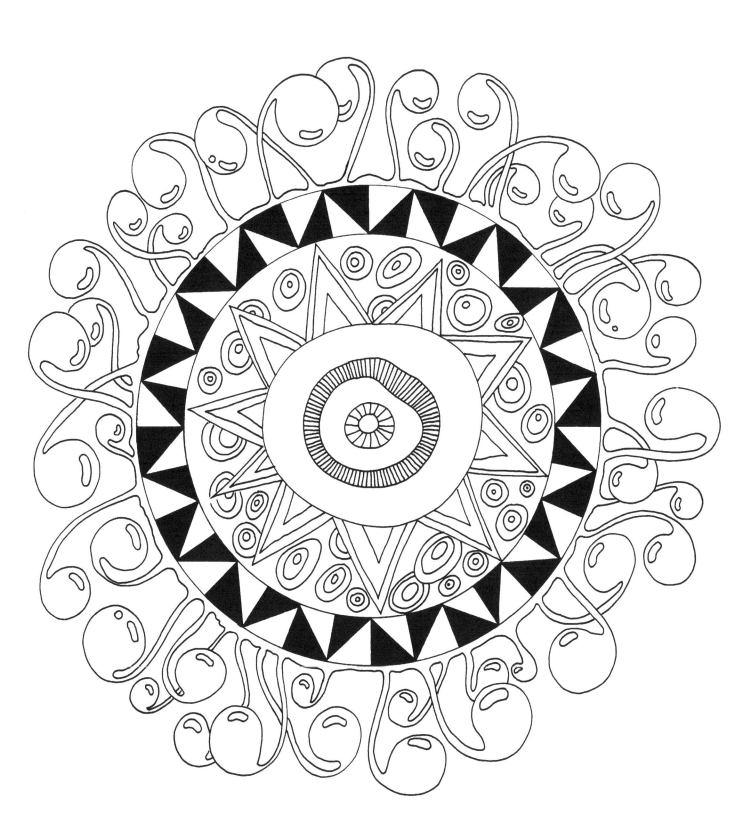

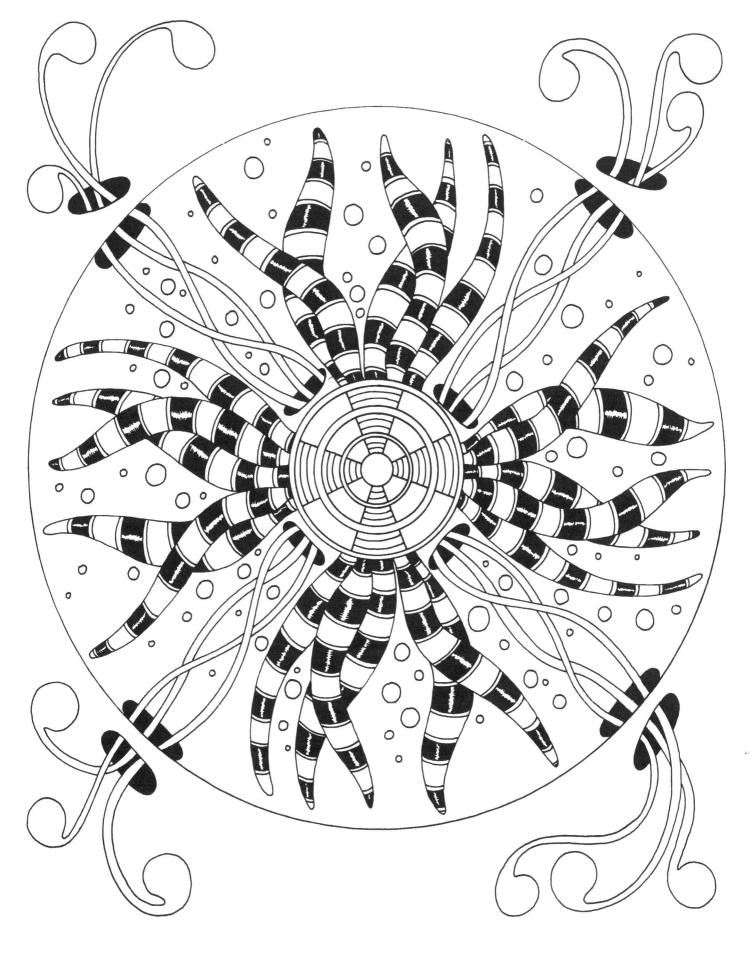

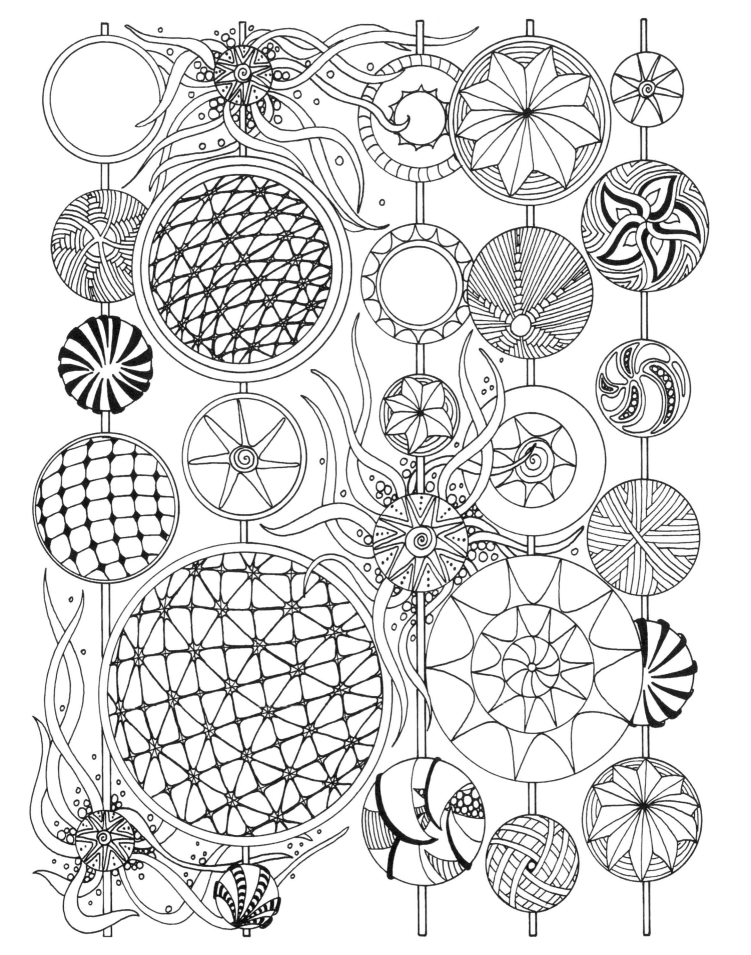

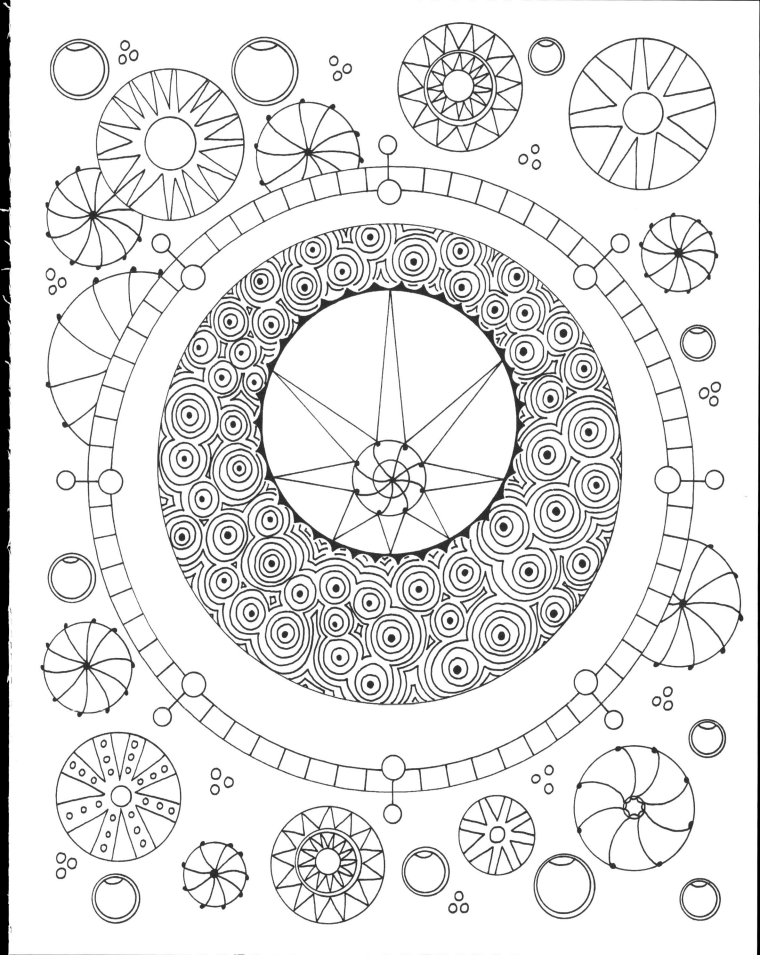

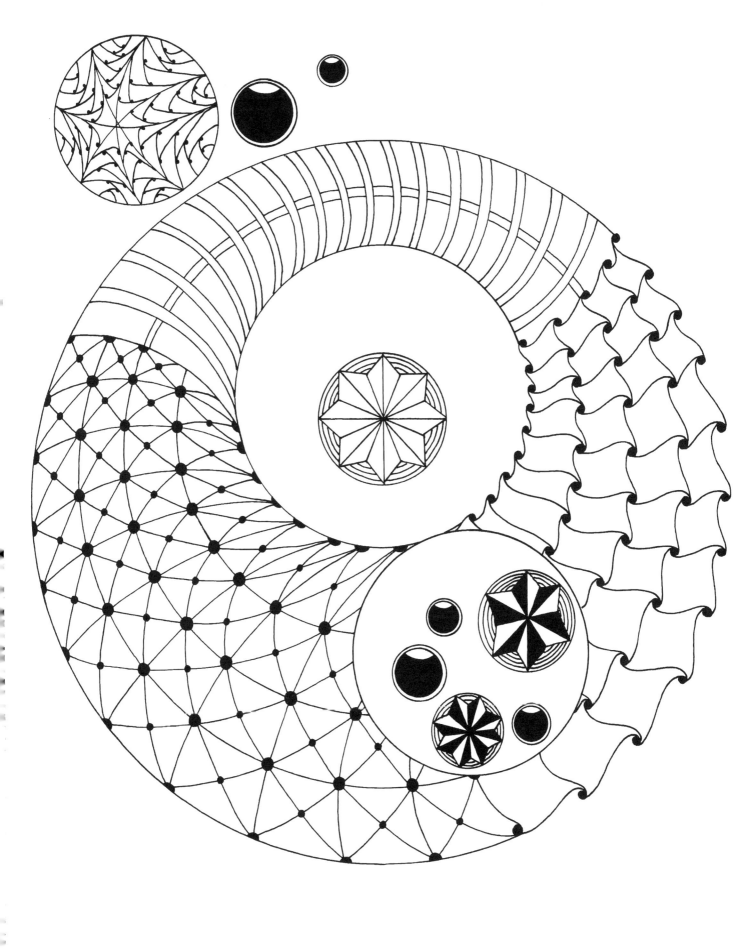

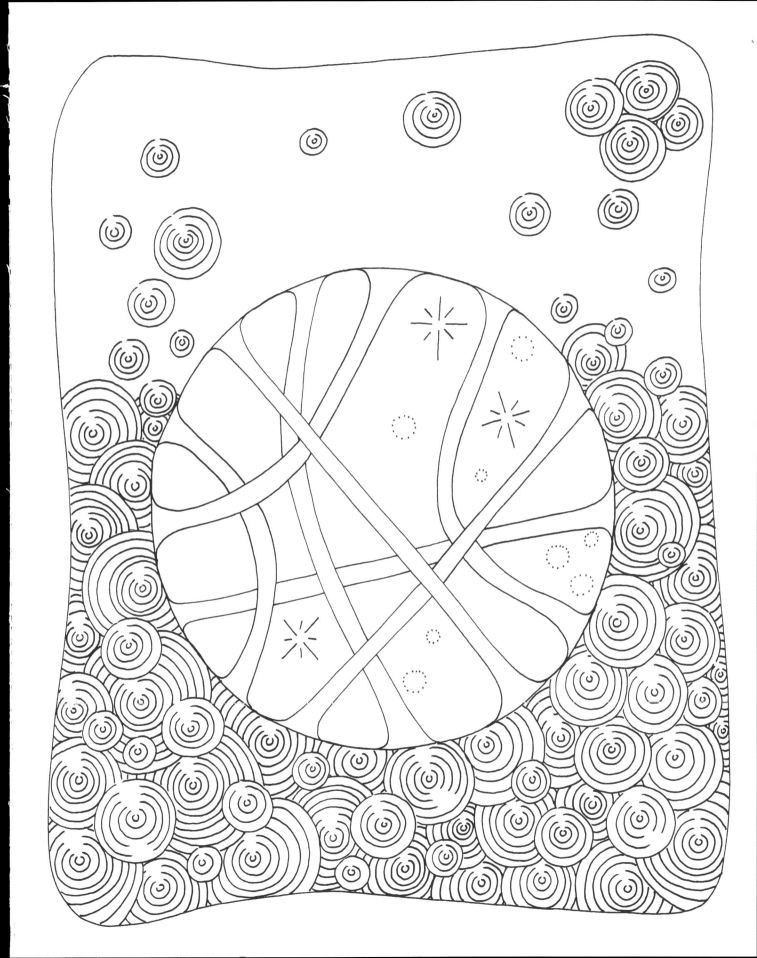

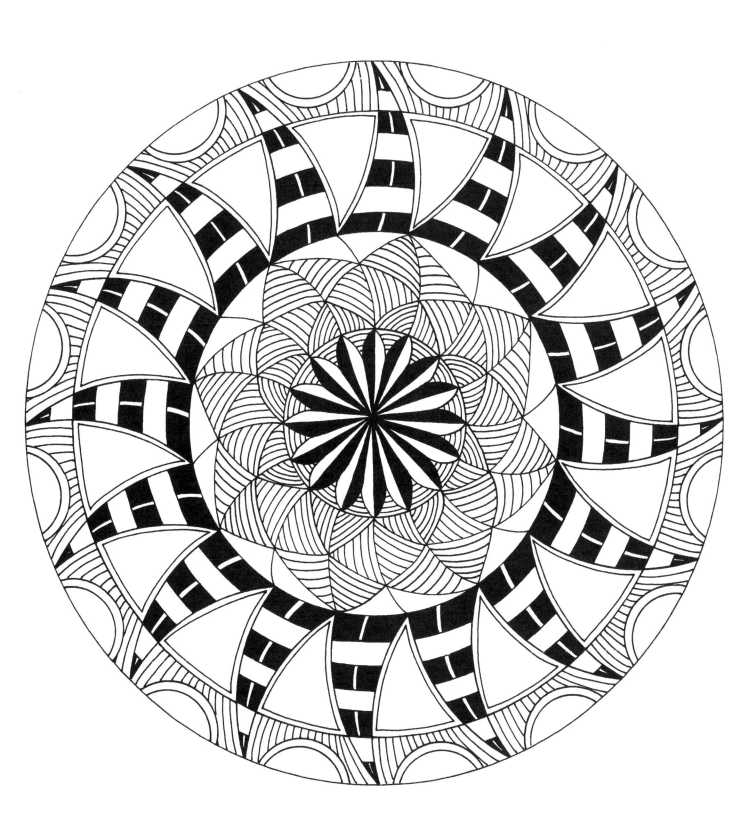

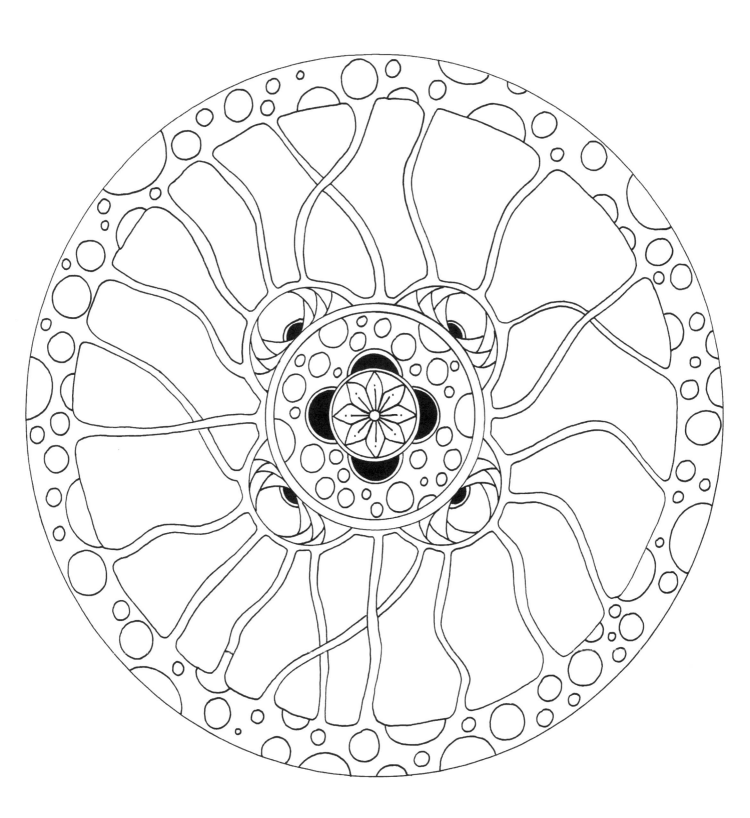

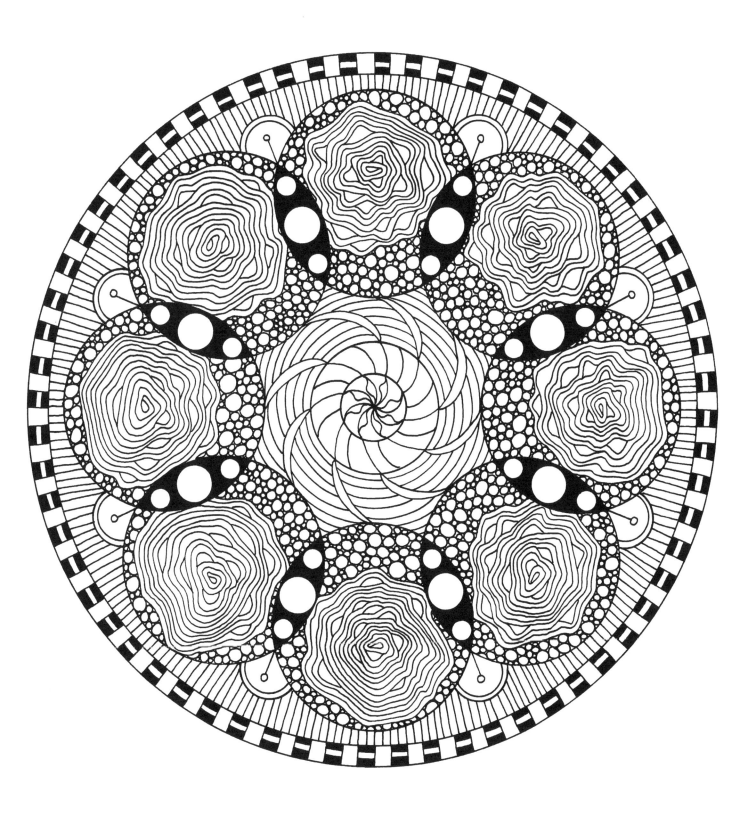

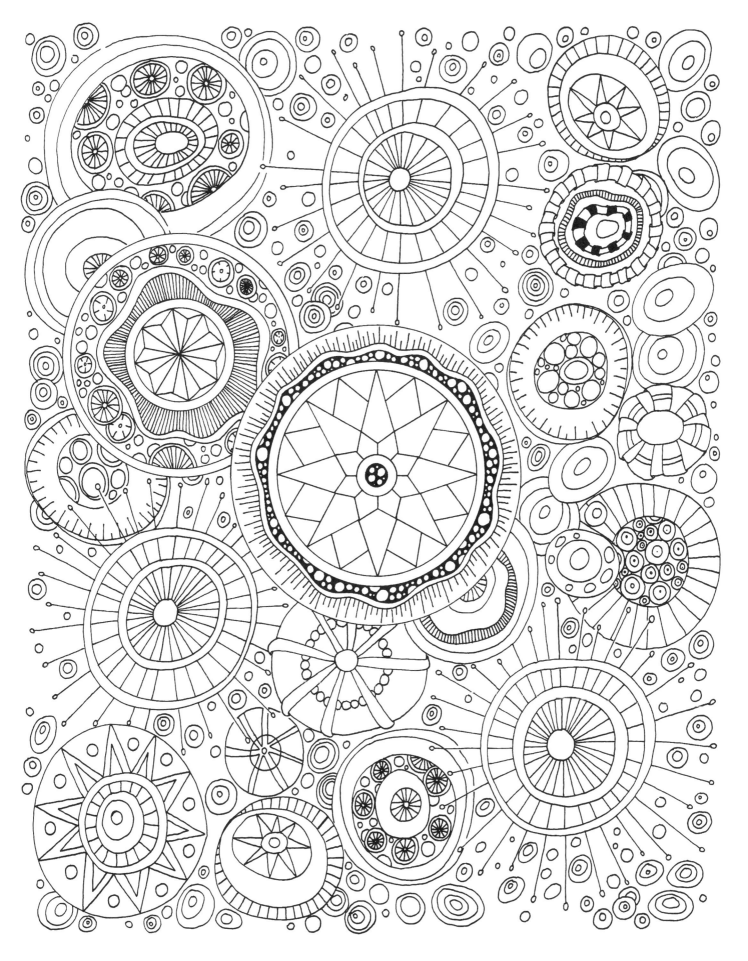

Complete the background circles by filling each one with patterns and stripes. See the corresponding example on the inside front cover.

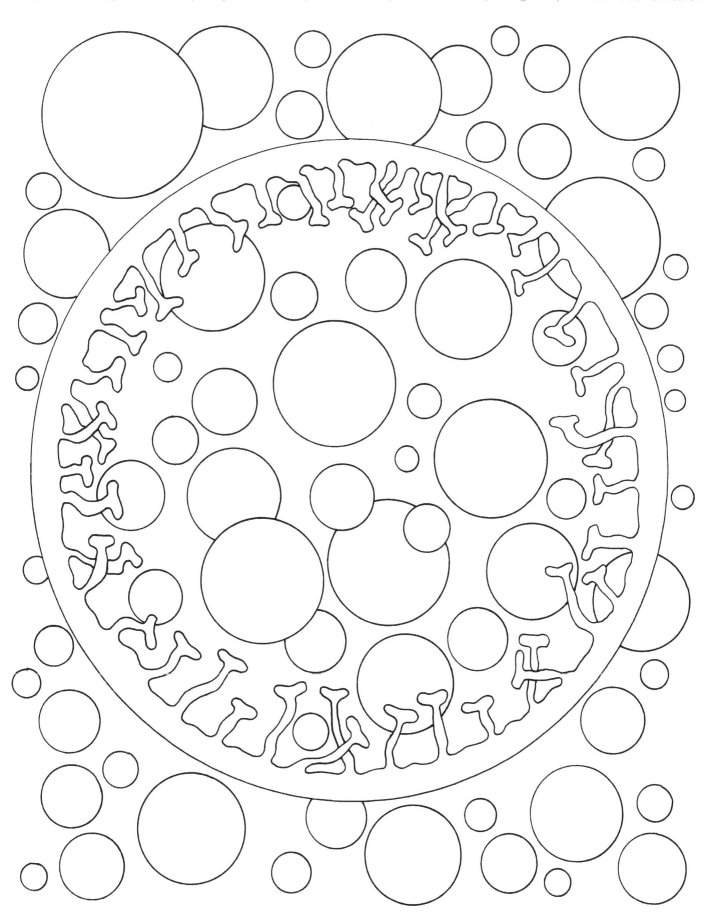

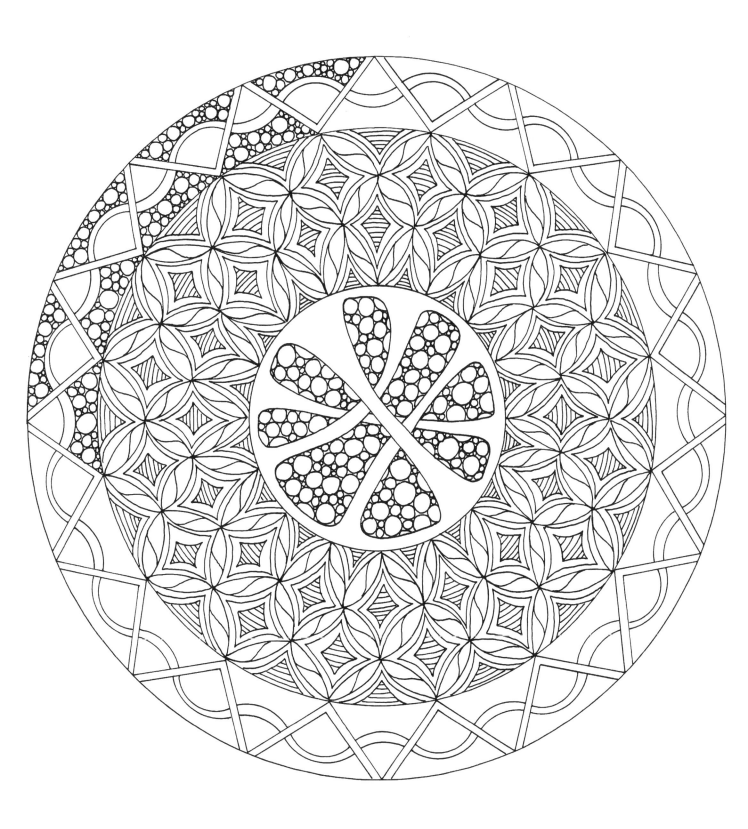

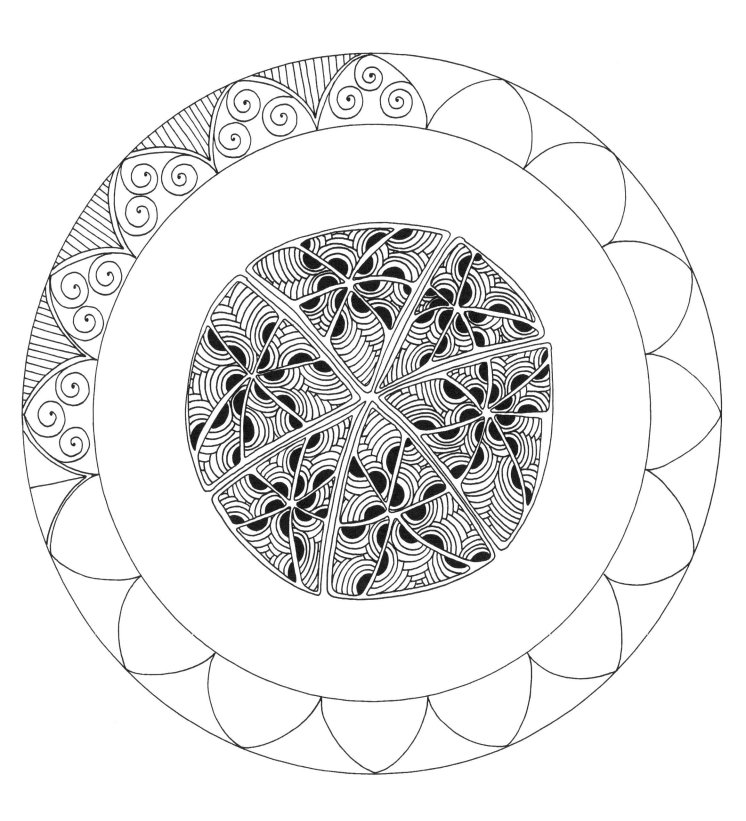

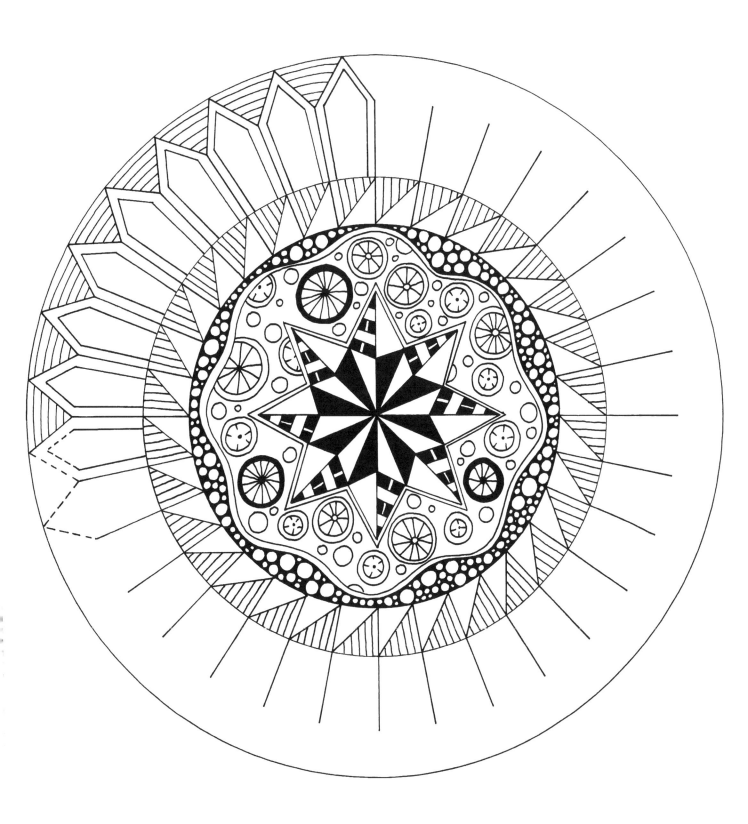

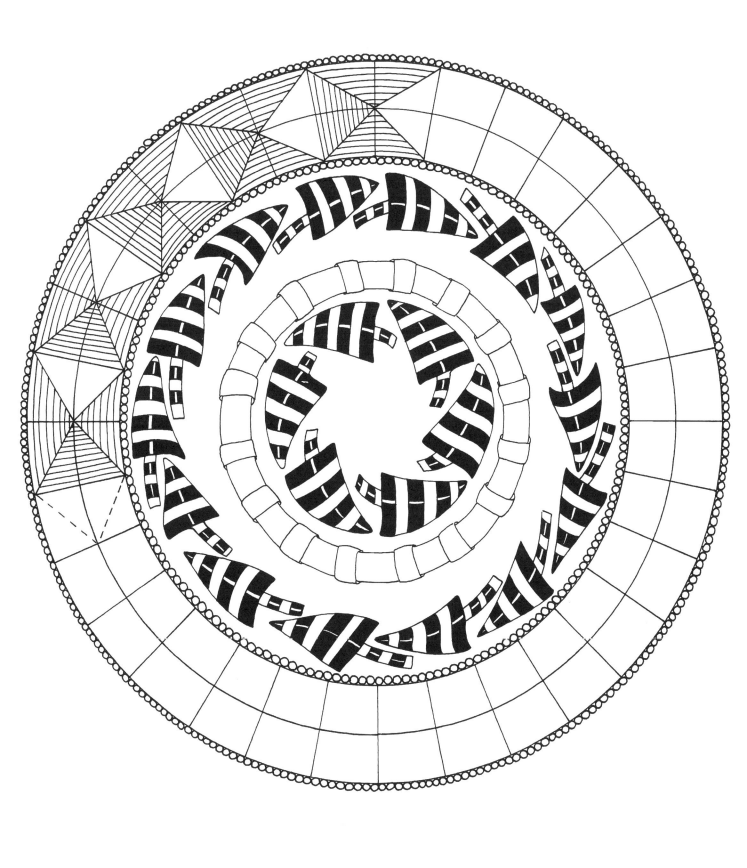

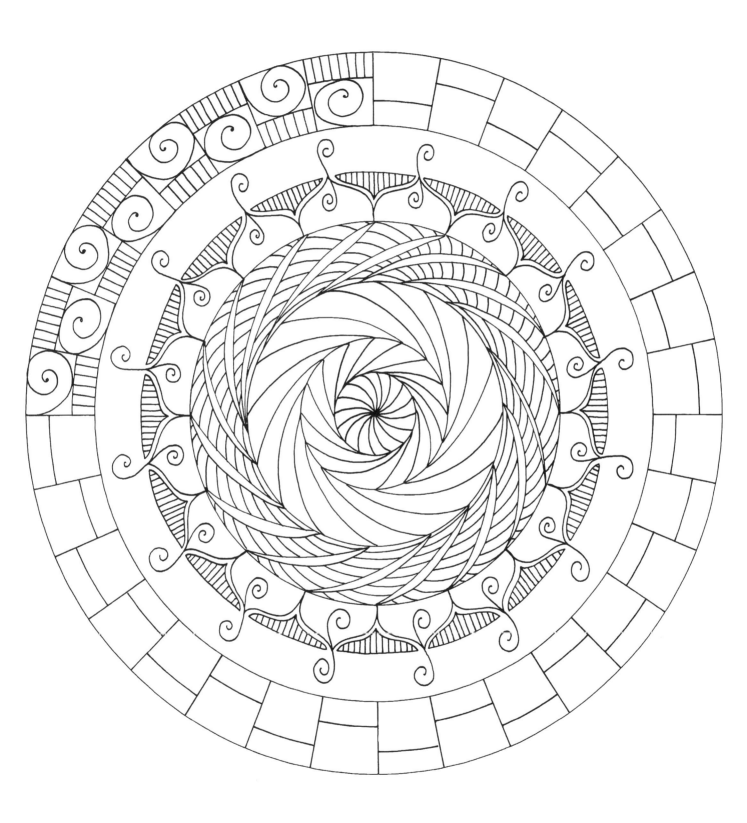

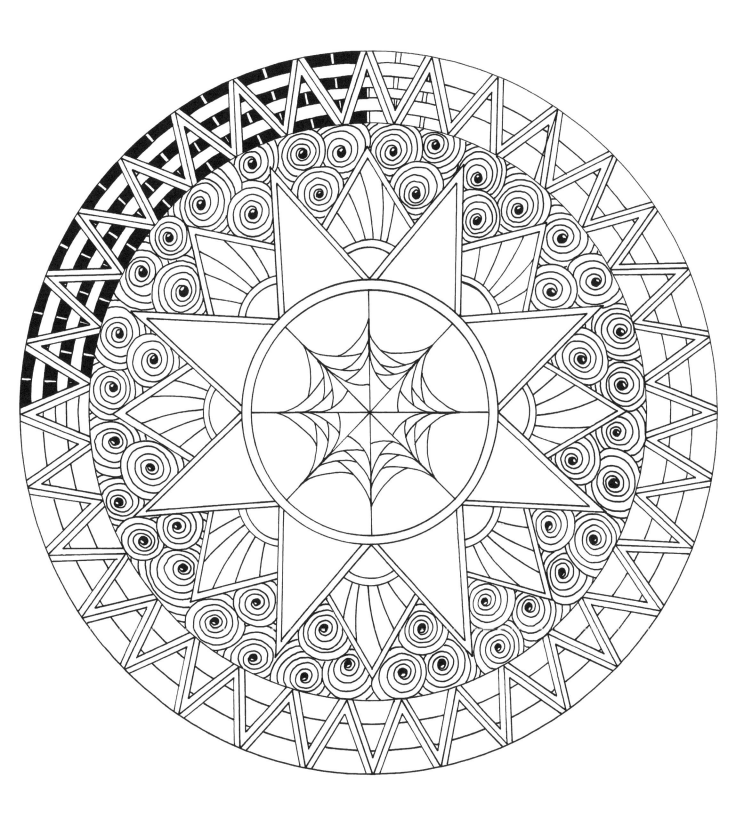

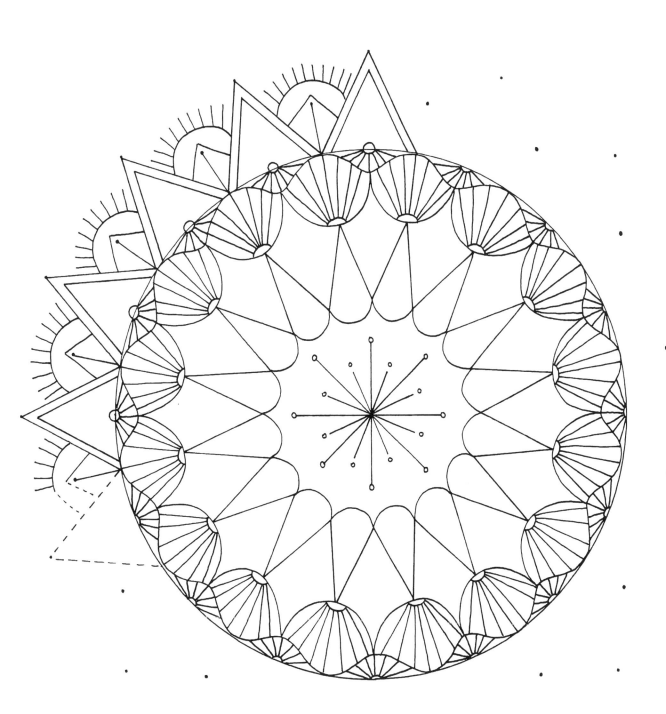

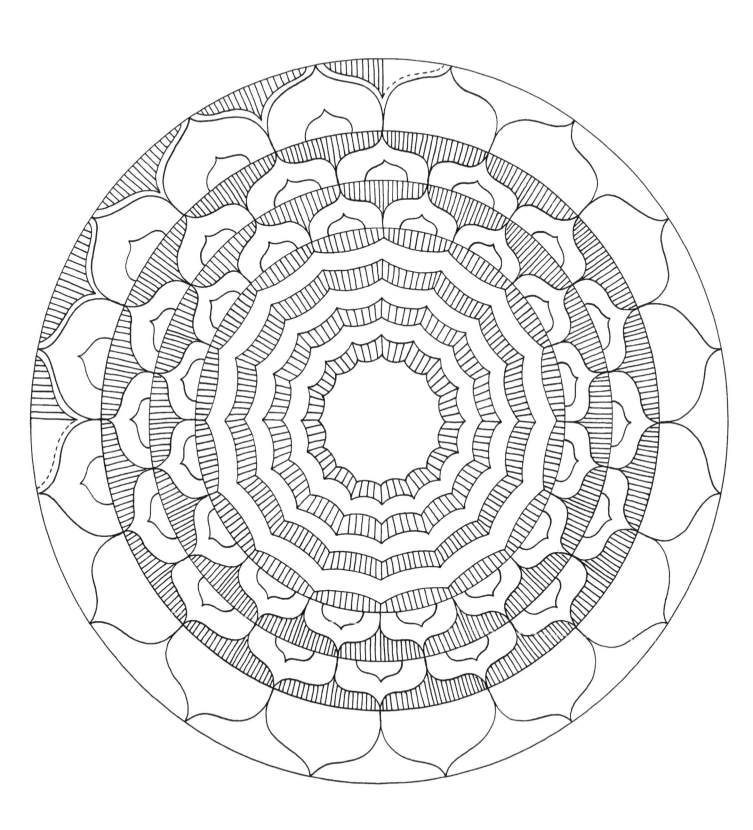

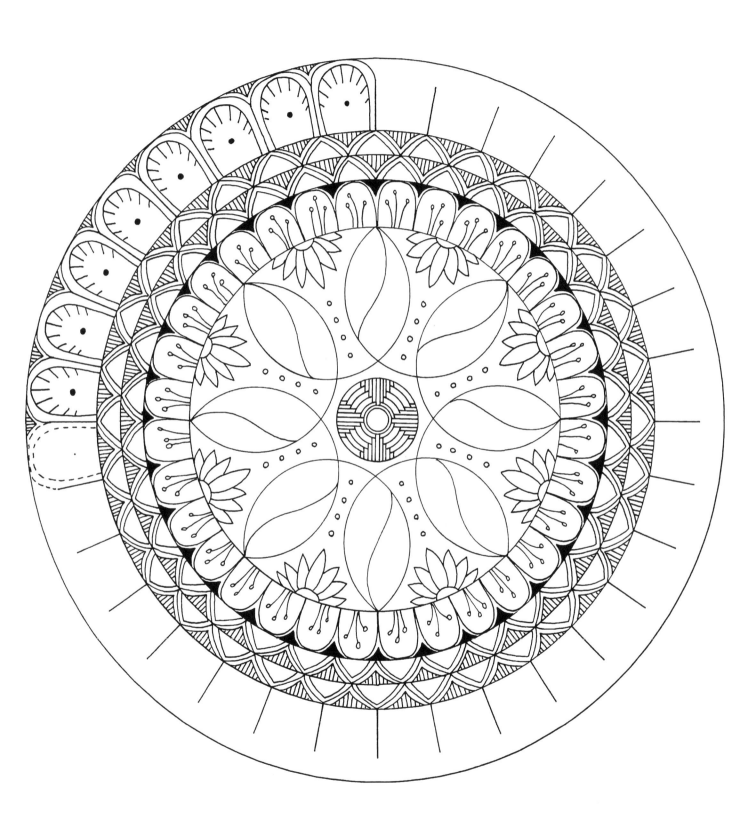

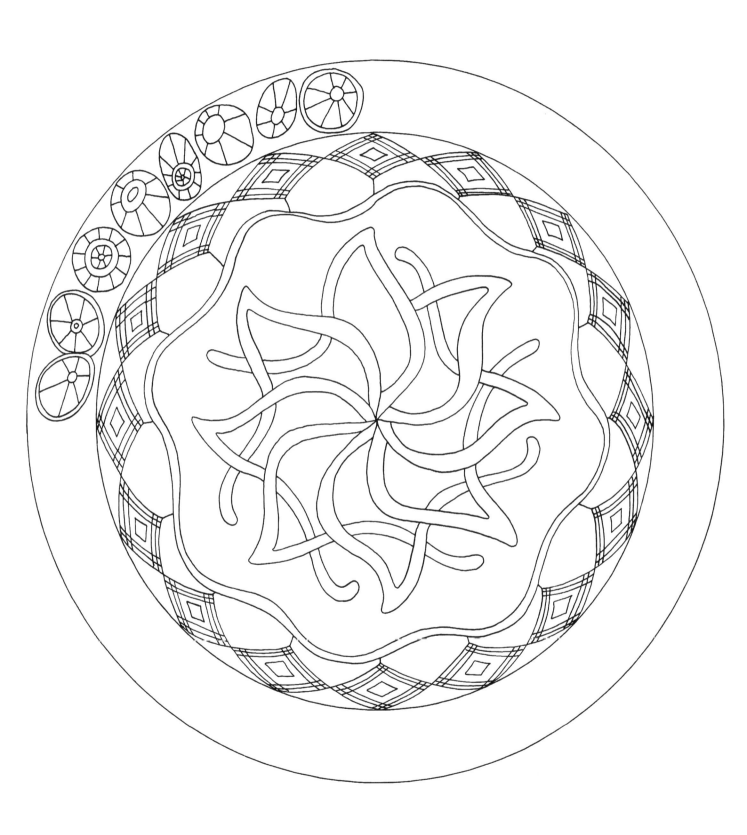

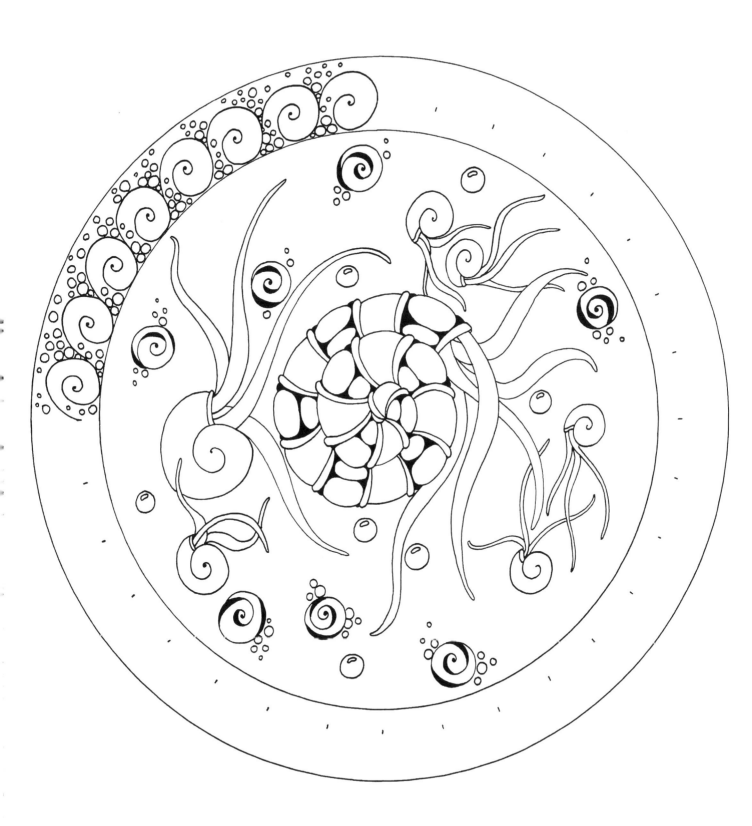

Complete the border. Use the lines as guides to draw the heart shape; add bubbles and straight lines.
See the corresponding example on the inside back cover.

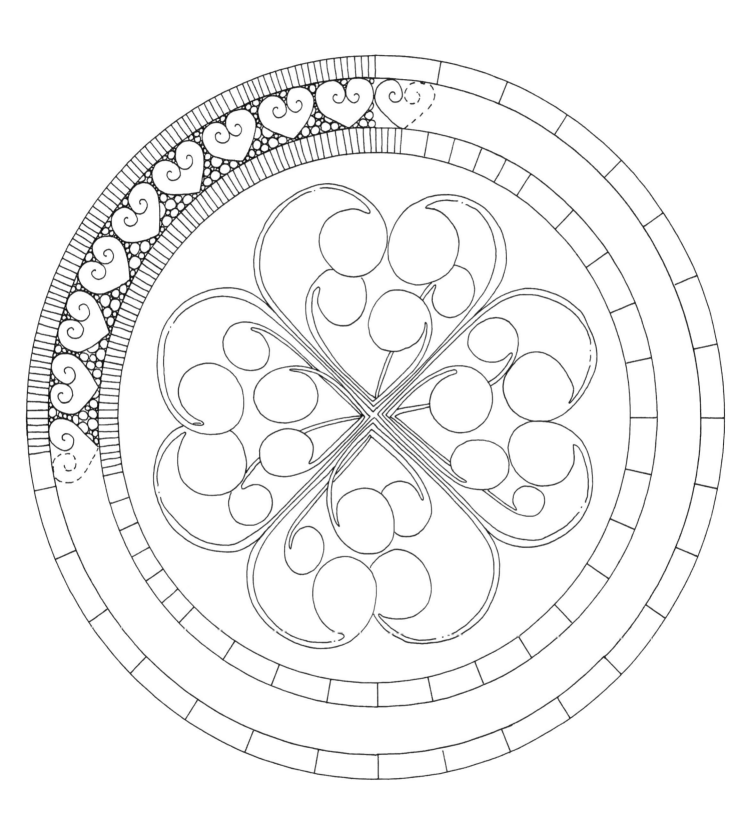

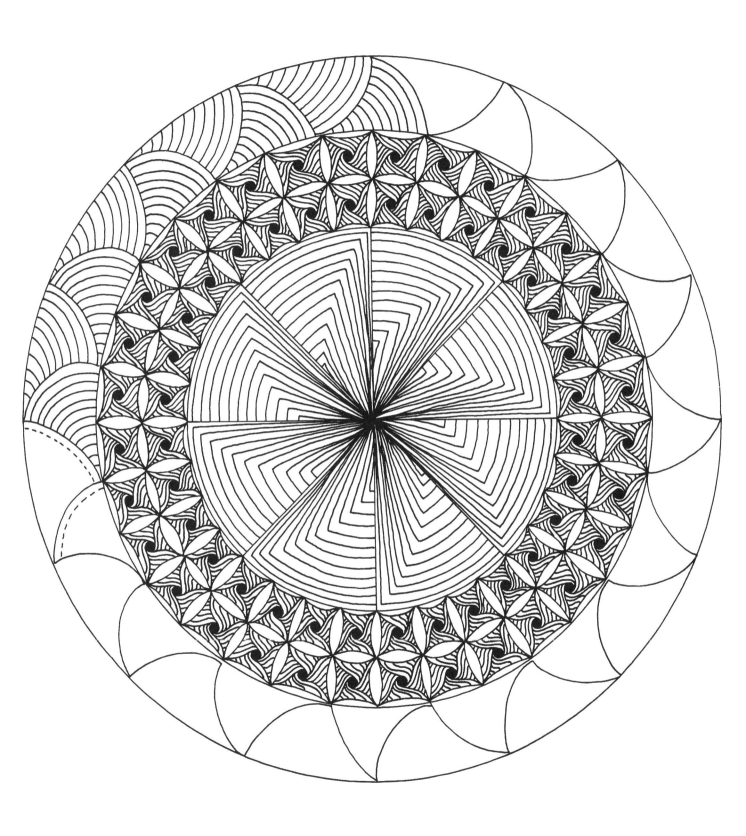

Complete the border. Then draw a triangle shape on either side of the existing line. Draw in three oblongs into each triangle and color in the background with black ink pen. See the corresponding example on the inside back cover.

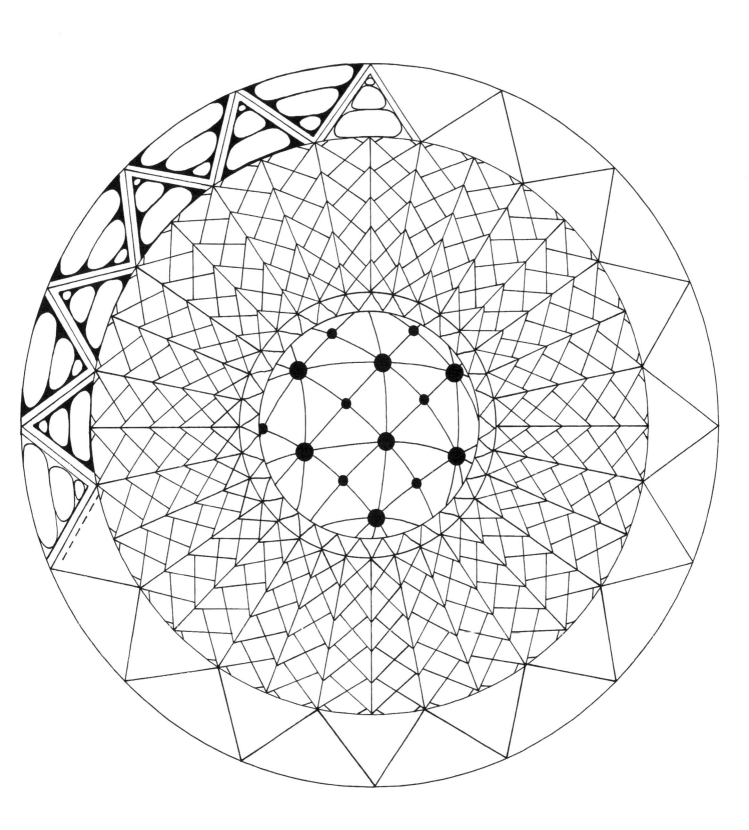

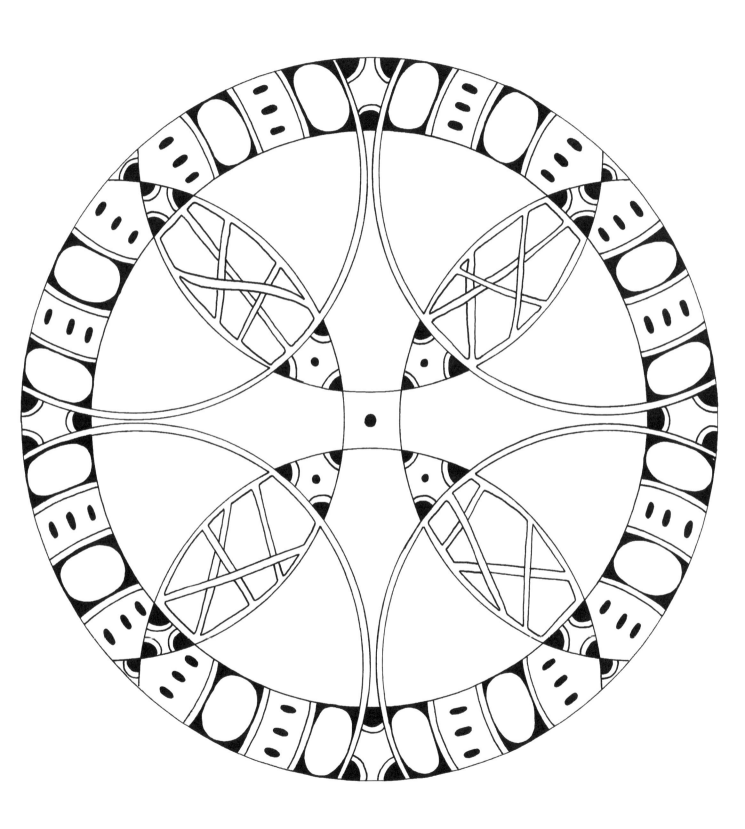

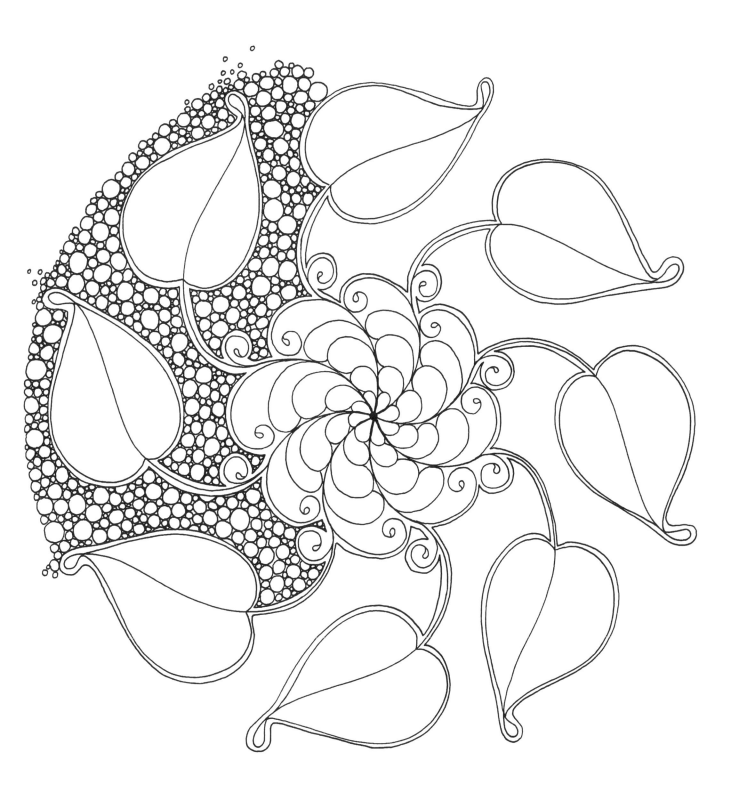

Complete the border. Finish the leaf shapes using the straight lines as the guide for each one.
See the corresponding example on the inside back cover.

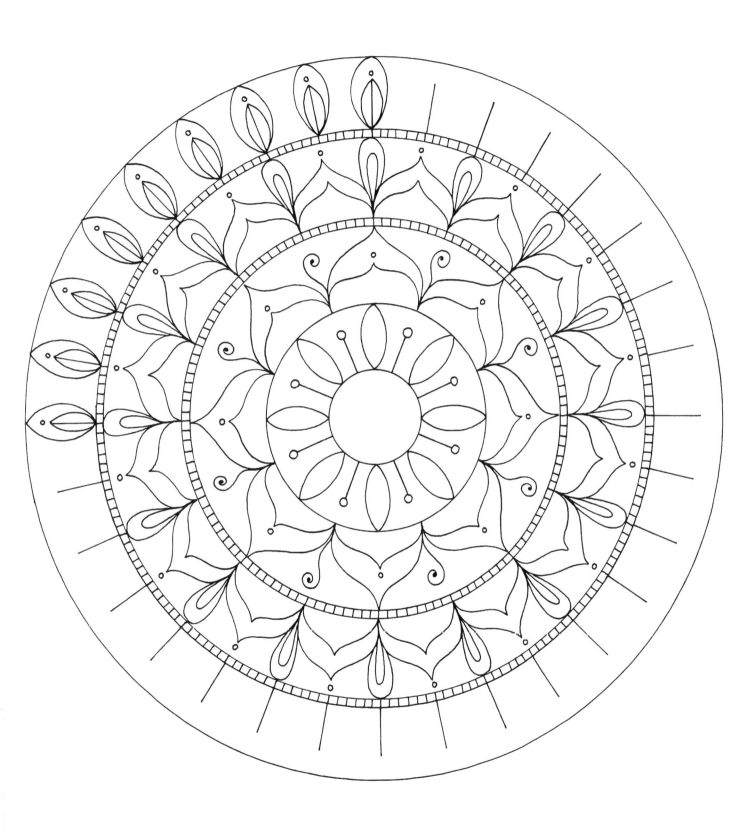

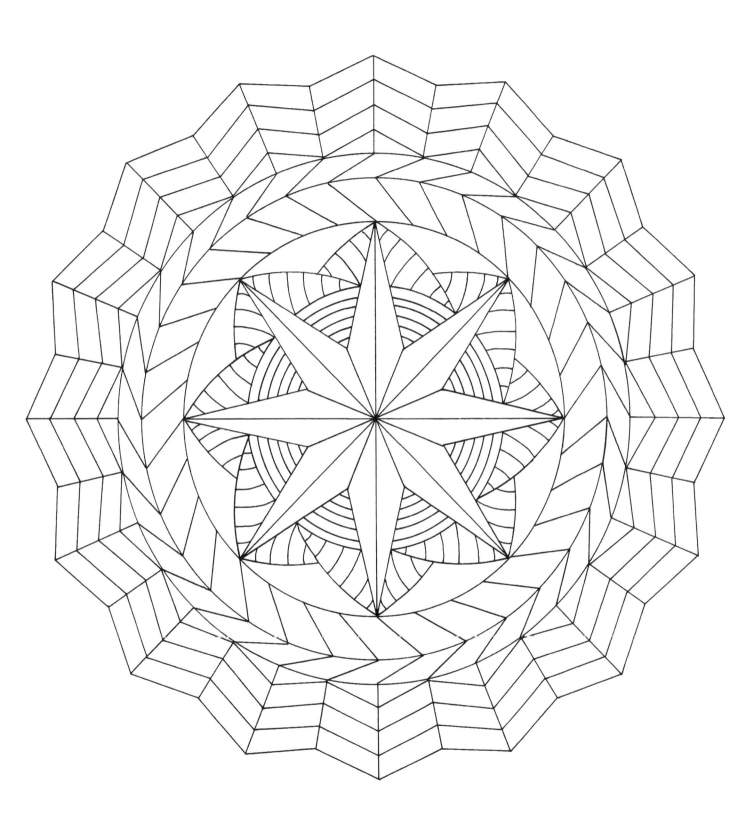

Complete the background. Color in each alternate square with either black ink or a color of your choice. Start with the inside circle first and work outwards to reduce the chance of errors. See the corresponding example on the inside back cover.

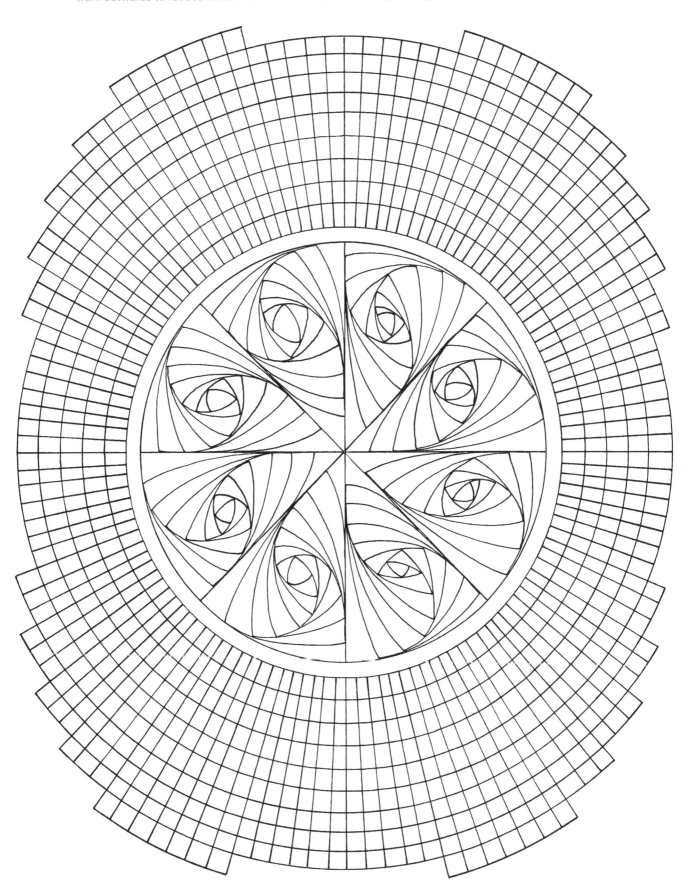

TECHNIQUE TRYOUTS

Use these sample pages to practice patterns and experiment with different mediums and color combinations.

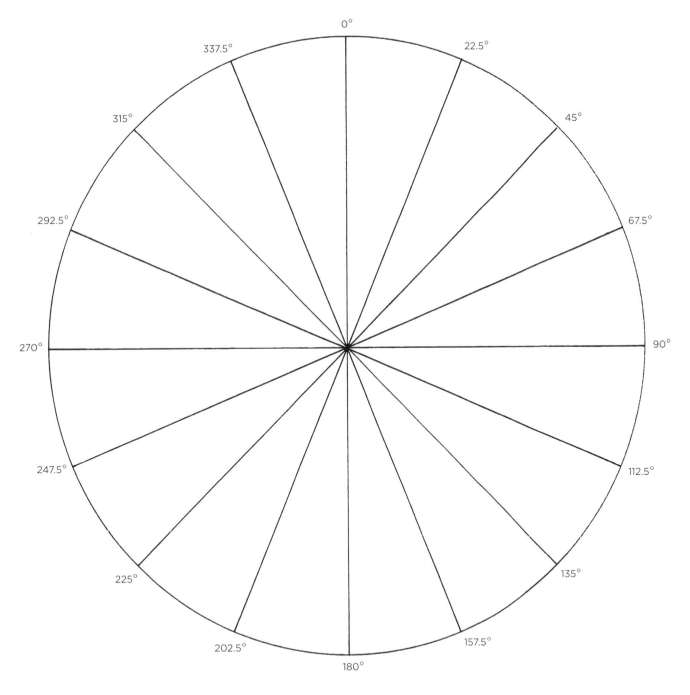

Sixteen-segment template with angles marked at the following points on a protractor:
0 °, 22.5°, 45°, 67.5°, 90° , 112.5°, 135°, 157.5°, 180°, 202.5°, 225°, 247.5°, 270°, 292.5°, 315°, 337.5°

Use the half-round mandala base skeletons to try out some of your own patterns.

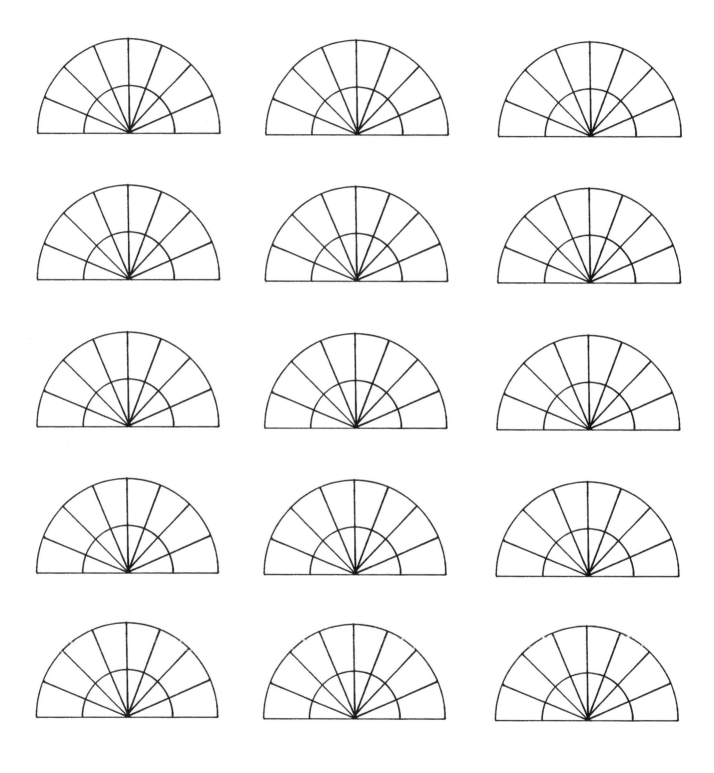

Color this mandala along with me. Refer to the section "Coloring Circles and Mandalas," page 15, for further instructions.

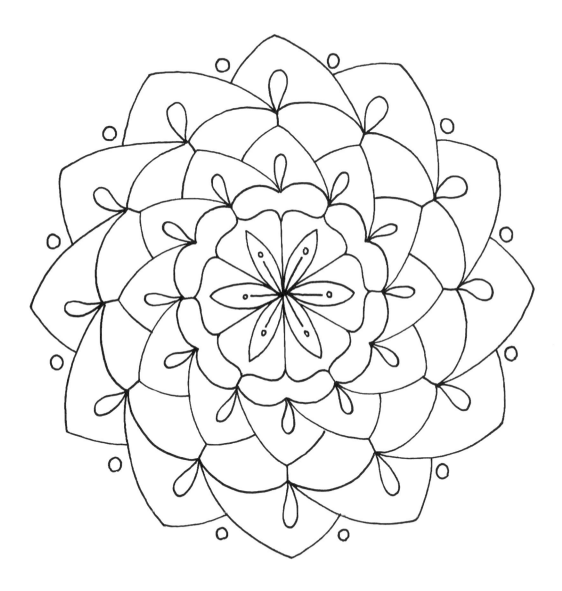

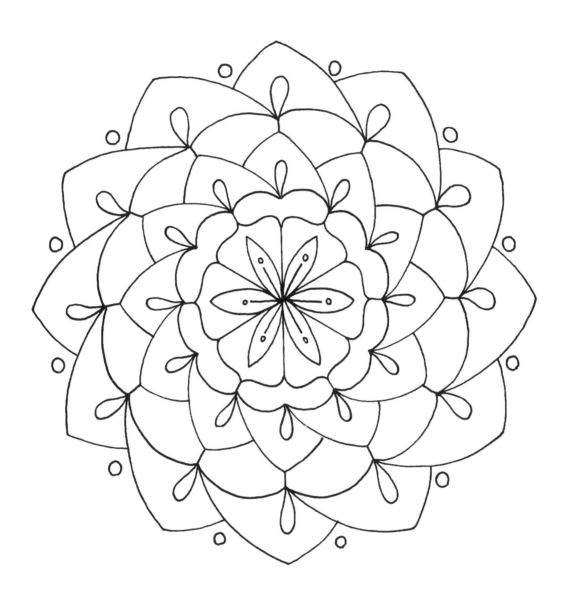

RESOURCES

Caran d'Ache
www.carandache.com/en/colour/neocol-or-2-watersoluble
Neocolor II water-soluble wax pastels

Faber-Castell
www.fabercastell.com
Polychromos colored pencils

Fabriano
http://fabriano.com/en
Artistico Extra White hot-pressed
watercolor paper

Sakura
http://sakuraofamerica.com/
Pigma Micron pens
Sakura foam eraser

Staedtler
www.staedtler.com/en/
Circle templates
Compass
Mars Micro 0.5mm mechanical pencil

Zentangle
www.zentangle.com
www.zentangle.blogspot.com

ABOUT THE AUTHOR

Jane Monk lives in Tasmania, Australia, with her husband James, son Jonathan, and three cats, Shadow, Merlin, and Jet. She is a self-taught artist who has been drawing since she was a young girl, inspired by the beauty in all things in the natural and man-made worlds. Patterns and repetition; the sometimes quirky and different; are what inspire her work. Drawing is Jane's first love and something she is compelled to do every day. Jane became a Certified Zentangle Teacher, in Class #4, in October 2010.

Website: www.janemonkstudio.com

Blog: www.janemonkstudio.blogspot.com

Email: jane@janemonkstudio.com

First published in the United States of America in 2017 by

Creative Publishing international, an imprint of

Quarto Publishing Group USA Inc.

400 First Avenue North

Suite 400

Minneapolis, MN 55401

1-800-328-3895

QuartoKnows.com

Visit our blogs at QuartoKnows.com

10 9 8 7 6 5 4 3 2 1

ISBN: 978-1-58923-949-4

Library of Congress Cataloging-in-Publication Data available

Cover Image: Jane Monk

Design: Rita Sowins / Sowins Design

Printed in China